THE
Archive Photographs
SERIES

AROUND
PLAISTOW

THE
Archive Photographs
SERIES

AROUND
PLAISTOW

by
George Taylor

CHALFORD

First published 1996
Copyright © George Taylor, 1996

The Chalford Publishing Company
St Mary's Mill, Chalford,
Stroud, Gloucestershire, GL6 8NX

ISBN 0 7524 0614 0

Typesetting and origination by
The Chalford Publishing Company
Printed in Great Britain by
Redwood Books, Trowbridge

Contents

Acknowledgements

I acknowledge the hundreds of people, including lots of children, who were happy to be at the receiving end of my camera and some who were unaware that they were being photographed. Many have written expressing pleasure at being included in the records.

My warm acknowledgement is to Howard Bloch who, as Local History Librarian for Newham, kept alive a keen interest in my photographs by organising exhibitions of prints in community centres and libraries and of slide lectures where we both took part. His enthusiasm included contact with academics, the local press and the BBC and he arranged the successful reunion for the 1935 Jubilee.

All the photographs, save the one of my sister before my time and the two of myself, have been taken with my camera and all the negatives I printed for the book have been preserved for the archives.

In conclusion, my greatful thanks to Jo, my granddaughter, for deciphering my manuscript and putting it into type.

Introduction

Plaistow – pronounced 'Plarstow' by the natives and 'Playstow' by strangers and the BBC – had its main development as part of West Ham from the second half of the nineteenth century. It became an industrial and residential overflow from London and is well documented. I commend *West Ham, a study in social and economic problems* recorded by E. Howarth in 1907 from a powerful committee which included W.H. Beveridge, the author of a report which changed the social history of Britain from 1945.

My parents came to West Ham from London around 1900 to set up house in a new suburb where housing was available for rent. This was in the form of a maisonette in Cambus Road and convenient for my father to commute to his job as a clerk in London by way of Plaistow station. Unfortunately the London, Tilbury and Southend Railway became chronically overcrowded by the housing expansion east of Plaistow and soon it became impossible to board a train. My father had to give up his job and seek another locally. This was a 'blue collar' job as a printing ink operative in the firm of Mason and Mason in Chargeable Lane. The family needed more room and moved to a house in New Barn Street in Plaistow which was where I was born. In 1934 I took the opportunity of photographing my father at work and also with a group of his workmates.

This book presents a picture of growing up in the New Barn Street area up to the year 1939. It was quite an eventful time with the Great War still on when I started school. I was to experience living in what is now Newham with easy and cheap access to such places as Woolwich and London in the inter-war period. My photographs of street scenes in Plaistow and London will appear strange in 1996 because of the almost complete absence of private cars. I can only remember one neighbour who actually had a car; an Austin 7 Tourer which he bought as a relief from the very large lorry which he drove on weekdays to deliver bulk sugar for Tate and Lyle. In 1930 I had my first driving license to drive a motorcycle, issued from West Ham Borough in the Grove, Stratford. I drove my very cheap and second-hand machine to work and within the first week of the new law of 30mph in a built up area, I was fined £1 by the court for exceeding the speed limit along the old Beckton Road. It was not a built-up area – there were cows in the field! The street lamps, which were gas-lit, had been put there as a demonstration by the Gas, Light and Coke Company. At that time there was no requirement for insurance cover and it was many years before protective helmets had to be worn.

The thirties also saw rapid technical advances in wireless and even the start of the first television broadcasts although few could afford the set. The cinema was very popular and we

had the first talkies in the Carlton, Upton Park with Warner's Vitaphone technique. Musical productions in the theatre were very popular. I was given the opportunity to photograph from anywhere in the auditorium the stage performances of such shows as *The Desert Song* and *The Vagabond King*. In photography there were many rapid advances in films, colour and small cameras with results which were significant to me for the recording of people and events for print exhibitions and slide presentations. Such is my background which may be of interest to people and their friends and relatives with connections in Plaistow and West Ham.

The outstanding public event in 1935 was the Silver Jubilee of King George V and Queen Mary when everyone seemed to celebrate in their own local community. Being one of the few people to own a good camera at the time, I decided to use 6th May to record the event. I was enthusiastically received and had full co-operation from neighbours and friends. This probably represents a unique archive of one day in the lives of people where only the head of the family had a regular job and many were on the edge of abject poverty when casual work was the rule. Yet all looked upon this day as a time for celebration in communities which were completely honest and helpful to one another.

I remember well during my early childhood the events of the Great War with the Zeppelin air-raids, a bomb dropping on a house in Balaam Street and an AA shell fuse coming through the roof of our house in New Barn Street. I recall the sight of a Zeppelin coming down in flames and also the Silvertown explosion when the sky was deep red and our house suffered a cracked fanlight. The end of the war was celebrated in spring 1919 when we had tea on the tables in New Barn Street and a neighbour's little girl tore the red, white and blue paper suit which my mother had made for me!

We have had another war since then during which our old house was destroyed and the site levelled over but many houses survived and more recent photographs remind us of the old days (minus the ornate iron railings and gate which were collected for the war effort in 1940). It is to be hoped that those with an interest in Plaistow and West Ham will find this book a comprehensive and lasting record of early days.

George Taylor

One
Living in Plaistow

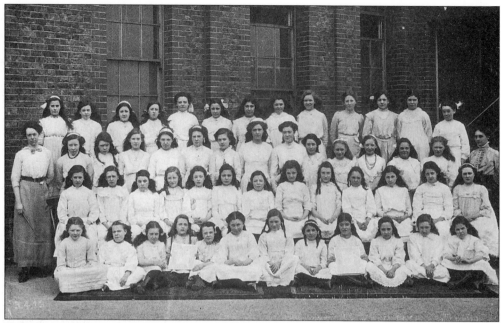

Holborn Road School was where all the children went from this part of Plaistow. In 1912 the girls' choir achieved success in the competition organised from the Crystal Palace. My sister Elizabeth is first on the left on the front row.

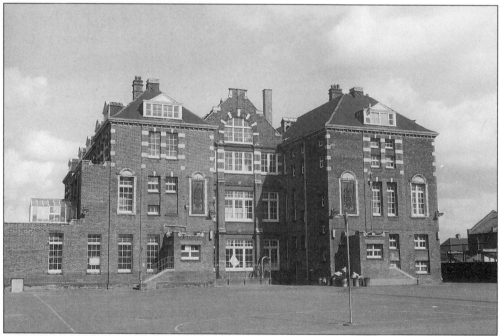

The school building remained unchanged over the years except for the removal of the green corrugated iron fence with a spiked top. This used to separate the girls and infants on the left, (who had classes on the middle and lower floors), from the playground on the right where the boys assembled to march to the top floor. The school has been reorganised in recent years and re-named Cumberland School.

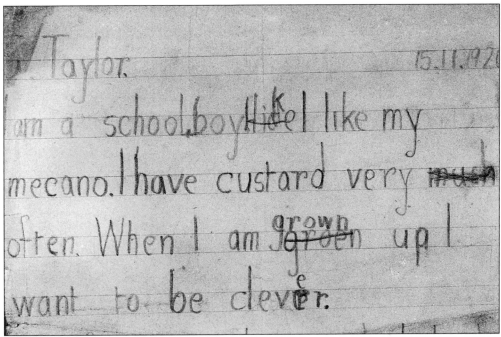

Taylor. 15.11.1920

am a schoolboy Hike I like my
mecano. I have custard very much
often. When I am gorten grown up I
want to be clever.

My first attempt at putting my thoughts into words at the age of seven. One could only write on paper after satisfying the teachers at the sand tray and slate tuition stage.

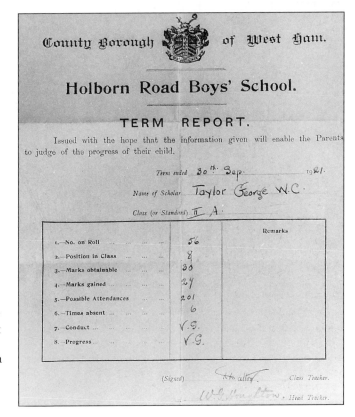

County Borough of **West Ham.**

Holborn Road Boys' School.

TERM REPORT.

Issued with the hope that the information given will enable the Parents to judge of the progress of their child.

Term ended 30th. Sep. 1921.

Name of Scholar Taylor George W.C.

Class (or Standard) II A.

		Remarks
1.—No. on Roll	56	
2.—Position in Class	8	
3.—Marks obtainable	30	
4.—Marks gained	24	
5.—Possible Attendances	201	
6.—Times absent	6	
7.—Conduct	V.G.	
8.—Progress	V.G.	

(Signed) Halley. Class Teacher.

W.G. Houlton. Head Teacher.

The term report of 1921 'issued in the hope that it will enable the parents to judge the progress of their child' with a class size of fifty six. Discipline was very strict and the cane was never far away. However it was seldom raised in anger but used to show authority rather than to hurt.

EXAMINATION OF APPLICANTS FOR
SECONDARY SCHOOL SCHOLARSHIPS.
1924.

ARITHMETIC (Part 2).

Choose any *ten* of the following.

60 minutes allowed.

1. If I pay a cab-driver one penny per minute and he drives 3½ miles in half an hour, at what rate do I pay him per mile ?

2. A rectangular box without a lid is made of wood ½ inch thick. Its outside dimensions are :—14 inches long, 12 inches wide and 7½ inches deep. What weight of mercury will it hold if 1 cubic foot of mercury weighs 864 lbs. ?

3. In the following calculations some figures have been rubbed out and replaced by crosses (×). Rewrite these sums with the figures put in.

(a) Add	45·67	(b) From	298·367
	2·38	Take	xxx·xxx
	197·23		
	xx·xx	Result	129·873.
Total	276·54		

4. On a plan one inch represents 150 yds. If two places are 25·2 inches apart on the plan what is their real distance apart in miles and yards ?

5. At a church ⅔ of those present are women, ⅛ are children and ¼ are men ; the 16 others are the clergymen and the choir. How many are in church altogether ?

6. Express a speed of 20 miles an hour as one of so many feet a second.

[P.T.O.

The 'scholarship' papers for english and arithmetic may surprise some readers in 1996. Typical arithmetic questions in 1924 covered a wide field of knowledge in money, measurements, fractions, decimals, and the 'stock of hay for feeding horses'.

7. A man has to pay income tax at the rate of 2/3 in the £ on the first £225 of his income and 4/6 in the £ on the rest of it. If the total amount of the tax he pays is £64 13s. 9d., what is his total income ?

8. A rectangular plot of land measuring 160 yds. long and 77 yds. wide, costs a purchaser £140 19s. 0d. If this price includes the cost of fencing it at 1s. per yard and five guineas for legal expenses at what price per acre is the land itself being sold ?

9. From 5·9 metres of cloth as many lengths of 2·4 decimetres each are cut off, as possible, What length of cloth remains ?

10. A certain stock of hay should be sufficient to last 45 horses for 145 days. If one-fifth of the hay is found unfit for use how long would the remainder last 58 horses ?

11. If A can do a certain work in 9 days and B can do a similar piece of work in 11 days, how long should they take to do it if they work together ?

12. A lad whose weekly earnings are 17s. 6d. saves ½ of that sum every fortnight, when will he have saved 50 guineas ?

We see the income tax situation in 1924 and how a lad could put by money to save fifty guineas! I passed the examination and started at the secondary school at Stratford in September wearing my best blue suit!

SAINT CEDDS

SWIMMING

&

GYMNASTIC CLUB

Affiliated to S.C.A.S.A.

SEASON 1927

Headquarters:
THE BATHS, ROMFORD ROAD, E.15

AFFILIATED TO S.C.A.S.A.
A.D.A., L.W.P.L., E.C.S.
AND W.P.A., R.L.S.S. AND
L.D.A.

SEASON, 1934

Hon. Sec.: Mr. W. B. LOVELY
92 Wanlip Road, Plaistow, E. 13

Hon. Asst. Secretary: Miss MILLER
485 Barking Road, Plaistow, E. 13

Name Mr. G. W. C. Taylor

My club cards for 1927 and 1934 showed that, being a choirboy at St Cedd's church, I was able to learn to swim and also play billiards and chess. Plaistow United Swimming Club was very famous and I learnt to swim more effectively but not well enough to join the water-polo team. I remember Mr Ted Temme, a famed channel swimmer who was a member at that time.

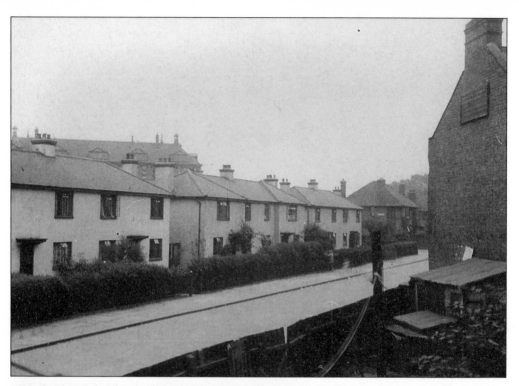

From my bedroom window in 1934.
Holborn Road School can be seen
in the background. My sister
persuaded me to throw a snow ball
from our garden at Miss Schottler,
the German infant governess at the
school, probably during the winter
of 1917-18 just before I started at
the school. I missed!

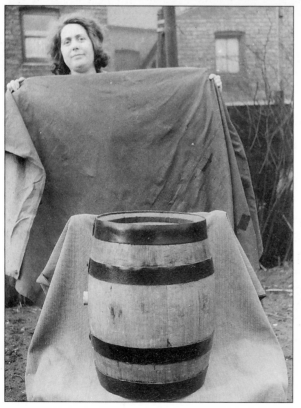

Our neighbour at the back, the first
house in Eclipse Road, was a
professional cooper who made
ornamental barrels in the yard in
his spare time. Mrs Bonser, his wife,
assisted in my photography of his
handicraft in 1935. I kept my
motorbike in his yard.

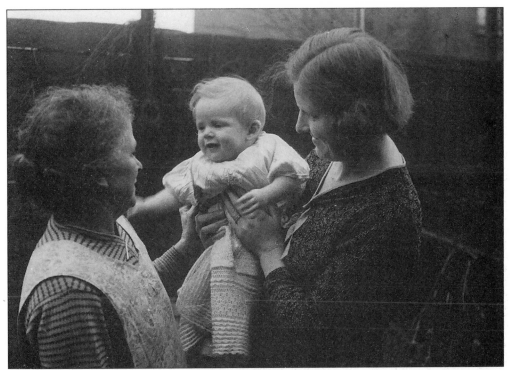

One took the best photographs by daylight in 1934 – most houses were lit by gas mantles at that time in Plaistow. This is my mother, my elder sister and my young niece Jean (who now has a flourishing art business!) in the garden of 109 New Barn Street.

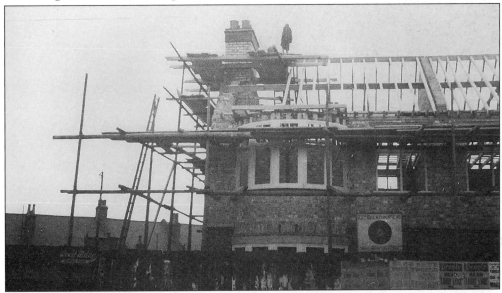

There had been an odd piece of land vacant to the north of New Barn Street parallel to Denmark Street. A pair of superior type houses were built in 1934 – note the large bay windows. I photographed the 'topping out' stage. To the left is a boot repairer's hut; this was previously a place to hire a bicycle at 3d per half hour. I once had 'fifteen minutes' share at 1½d of a small lady's bike with no brakes or mudguards – how I learned to ride!

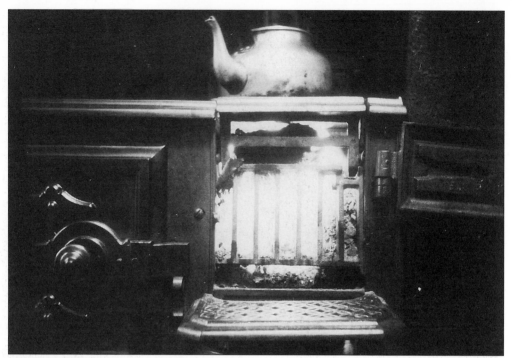

This is the 'Kitchener Stove' fitted as a principal source of heating and cooking for the houses in New Barn Street. Coal was kept in the cupboard under the stairs. The back scullery held a 'copper' which could be lit underneath for doing the washing or heating water to bathe in a galvanised iron bath.

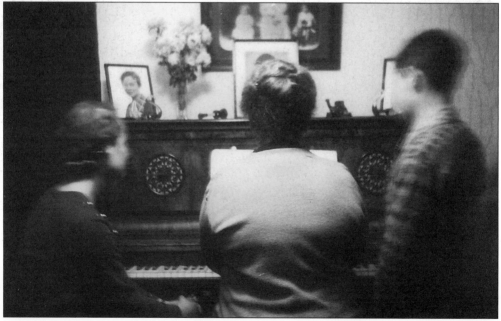

Mrs Ives and her son and daughter obliged the photographer by keeping still (almost!) for a couple of seconds. They were singing hymns at the piano in their house in Cumberland Road in 1934 by gaslight.

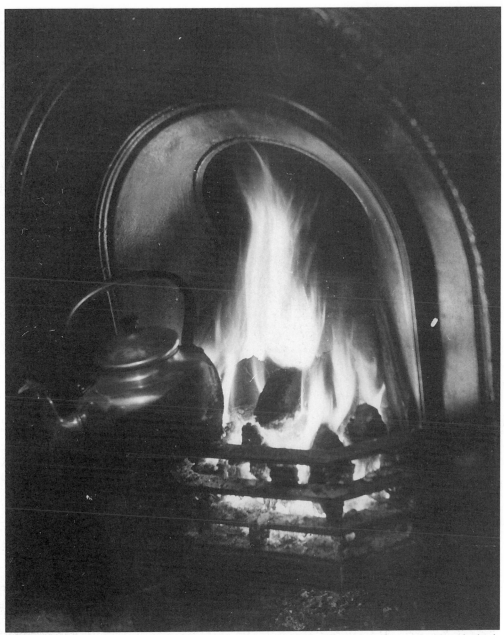

The front rooms and the bedrooms in the houses in 1933 had this type of open fire fitted which could have a hob to take a kettle to heat. This was used especially if there were two families sharing the house.

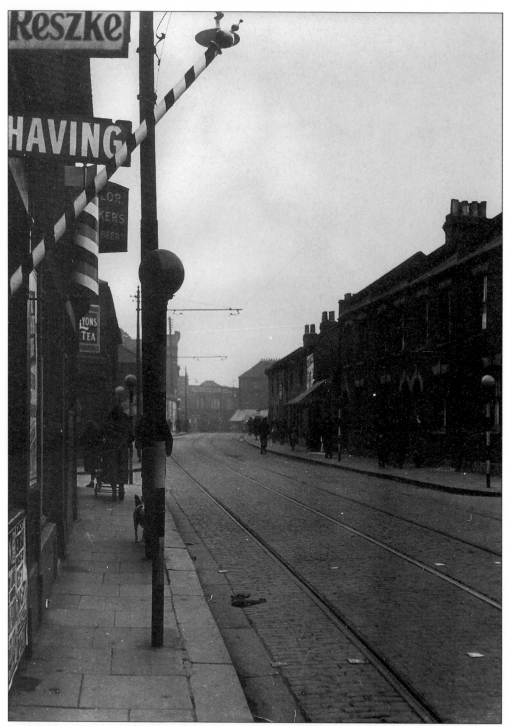

Looking north along New Barn Street one sees a collection of shops on the left hand side including the paper shop and barbers and the Army and Navy pub. This was moved down the street after the war. The Abbey Arms is at the crossing at Barking Road and Balaam Street.

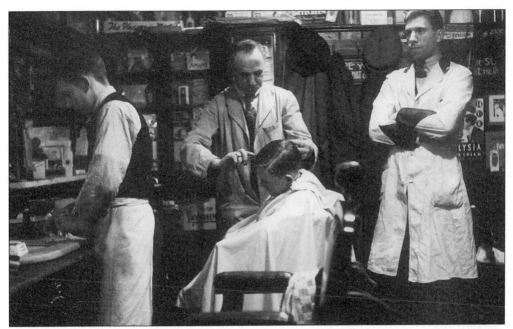

At the other end of New Barn Street there was another barber's shop where Percy Smith cut my hair when I was a small child and helped me to sit on a board across the chair. The main topic for conversation seemed to be the West Ham United Football Club. The fixture list is on the wall to the left of the lather boy and the greeting was, 'So they lost again on Saturday, Perce!' Photographed in 1933.

When I was about three years of age my sister first took me along to the blacksmith's shop near the Abbey Arms and 'bunked me up' to look over the half-gate to see the horse being shod. They were difficult to see being the black funeral horses from Hitchcocks the undertakers just over the street. Recently, I was asked by a lady living in Rotterdam House, just to the right, to provide a statement about when the blacksmith was operating to help in her efforts to preserve the site.

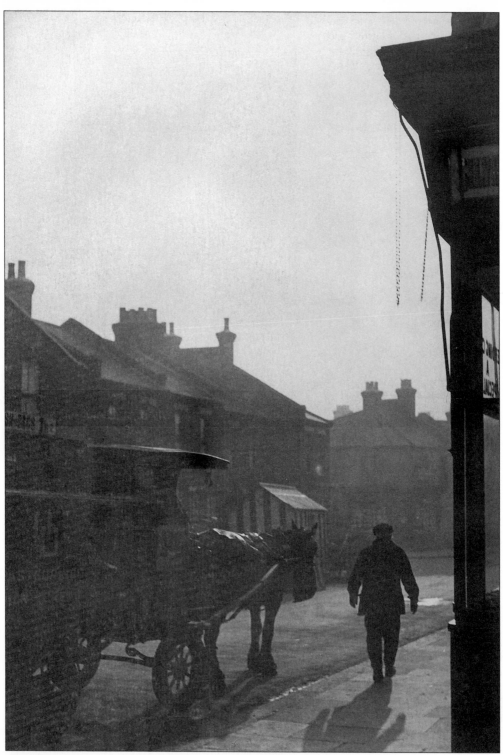

The milkman's horse having its lunch during a break in Adine Road between Barking Road and New Barn Street. The horse appears to be shackled so that he will not stray.

A view from Boundary Road on the eastern extremity of Plaistow into Denbeigh Road with an almost complete absence of cars, 1934.

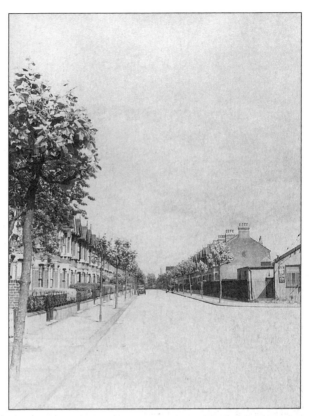

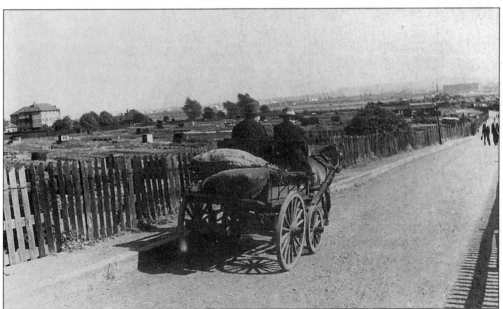

From Boundary Road to Boundary Lane, one goes over a small hill of the Northern Outfall Sewer which this cart is descending en route to the allotments. On the left is the East Ham Isolation Hospital and in the distance are the Royal Docks and the meat cold store building on the right.

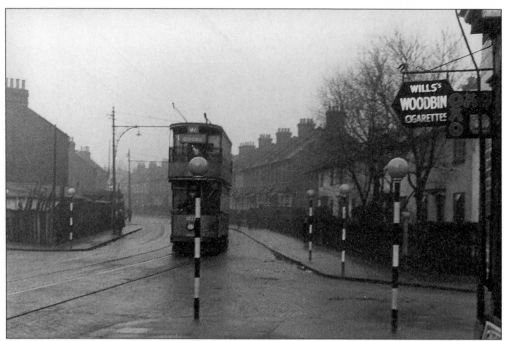

New Barn Street junction with Denmark Street and an abundance of Belisha Beacons. The West Ham tram is an earlier type with open ends on top, the joy of schoolboys and the despair of tram drivers. Note the fire alarm, the advertisement on the shop and elaborate tramway posts c. 1935.

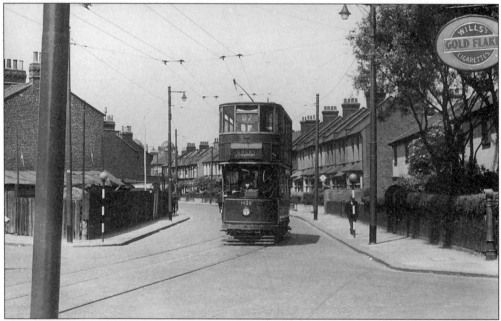

The same site in early 1937 showing an improved type of tram on loan from the L.C.C. with fully enclosed top deck. The wires on new posts are ready for trolley buses. Some of the Belisha Beacons have disappeared and the shop advertisement has gone up market and 'Woodbine Cigarettes' has been replaced by 'Gold Flake'. This is a number 97 via Stratford.

The same site with a sister tram but number 87 via Forest Gate is seen just before the advent of trolley-buses. On the first day of this event, 6 June 1937, a trolley-bus reversed here to turn round and demolished the fire alarm shown in the other photographs.

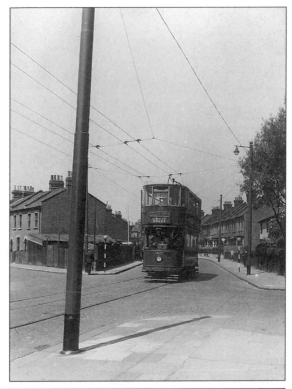

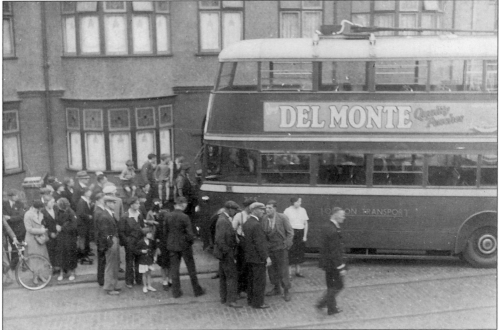

The tram drivers who moved on to the trolley-buses were not used to having to steer and minor accidents were more common. This one is in Green Street. The passengers were not used to the improved acceleration and when the trolley-bus started to move away it was too fast for the young men to jump on as had been their custom with the trams.

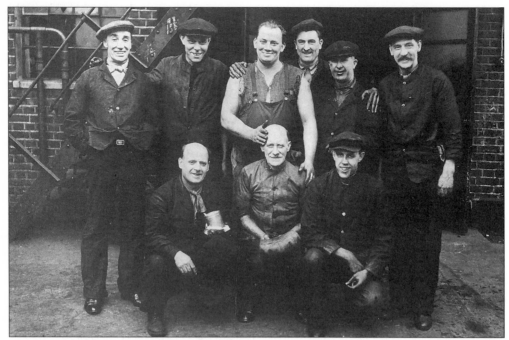

My father standing on the right with his workmates at the Empire Printing Ink works (formerly Mason and Mason). Mr Bell in the top middle was a fitness exponent. On the top left is 'Bluey' who looked after the processing of the blue printing ink. Photographed 1934.

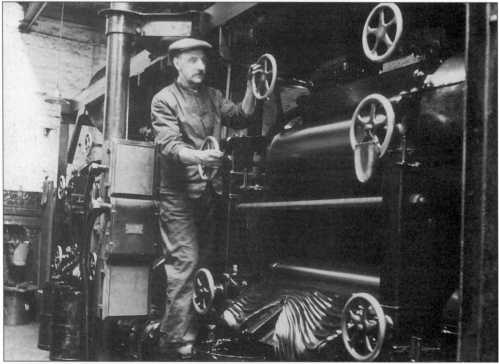

My father controlling the operation for grinding the black printing ink for daily newspapers. We took the *Daily Express* or the *Daily Mail* to check how it turned out!

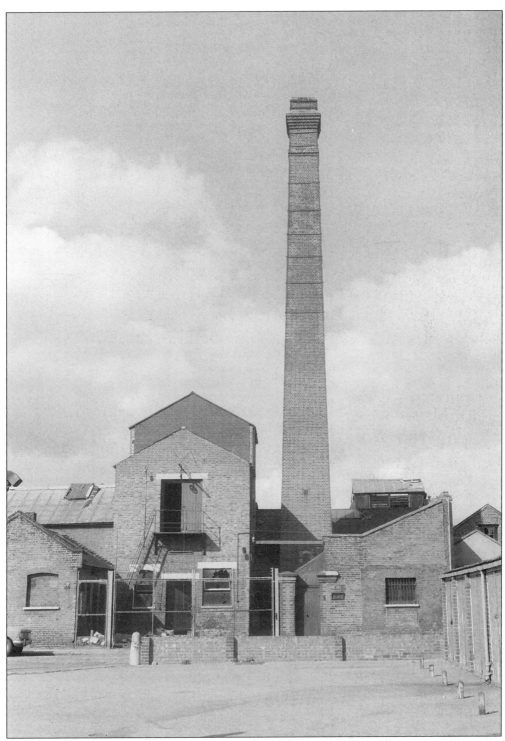

A view of the factory just before it was demolished for housing development. Plaistow lost the big smoke stack which had been a prominent landmark. In earlier years its boiler had powered the machines.

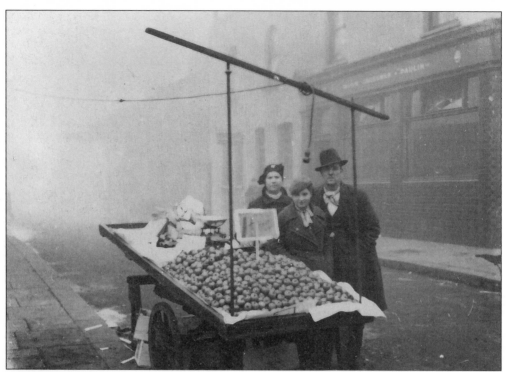

Warmington Street near the Abbey Arms. A simple set up for the costermonger and his family on a winter day in 1934.

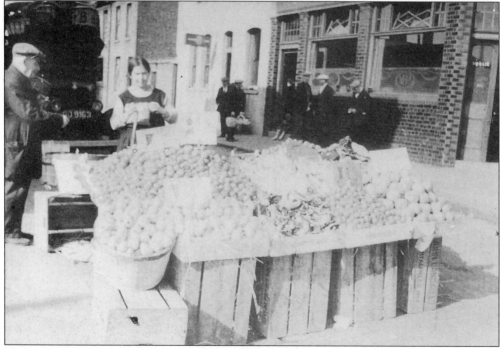

The same scene on a summer day in 1935 with more produce for sale and customers having a drink outside the pub. I believe this street was eliminated as a result of damage during the war.

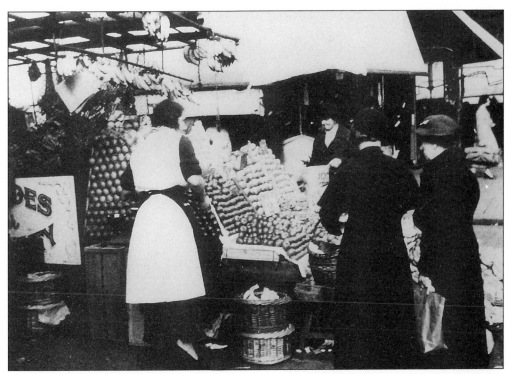

Fruit being bought by customers
at the stall next to Staddon's
shop at the Abbey Arms in 1935.

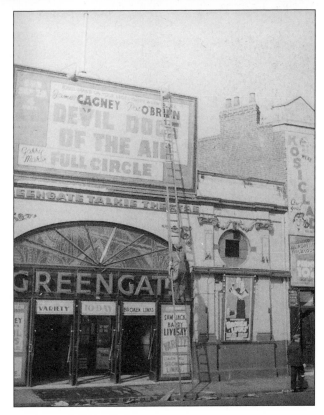

Bill-posting at the Greengate
cinema with James Cagney the
star. The window on the right is
the projection room. It was a
good place for a cinema, the
junction of Barking Road, Prince
Regents Lane, Greengate Street
and Tunmarsh Lane.

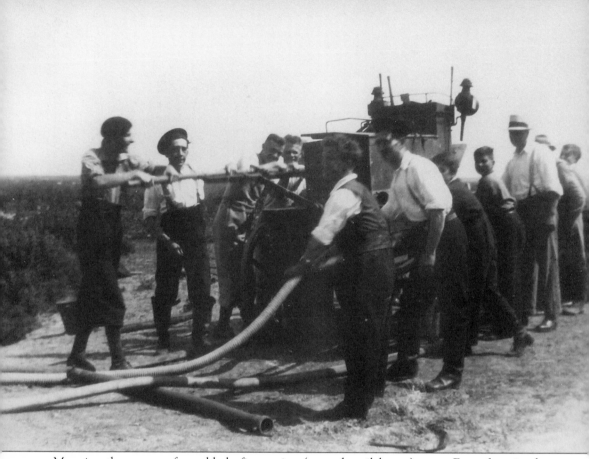

Manning the pumps of an elderly fire engine (note the oil lamps) at an Essex farm in the summer of 1931 where a number of haystacks were on fire. My friend and I were on an outing from Plaistow for a breath of fresh air! Instead we were requisitioned by the Essex Fire Brigade as temporary firemen for which we each eventually received half-a-crown by postal order. I am wearing the plus fours!

Two

Jubilee Day

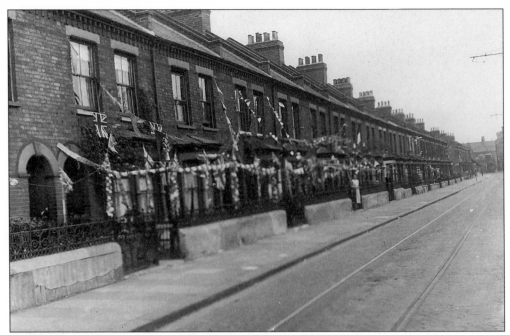

Preparations for the celebration of the Silver Jubilee of King George and Queen Mary, 6th May 1935. In New Barn Street we could not put up the tables in the road because of the trams so the front garden space was used. At the corner with Beckton Road is the Mission Hall we called the 'Lamb of God' to which my sister took me when I was about six years old on Sunday afternoons. When we had enough attendances marked we went on the outing which was by horse-brake to Rigg's Retreat in Epping Forest – a memorable time.

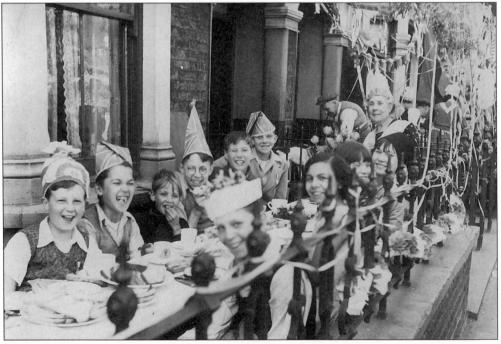

Mrs Jenkins, our next door neighbour, supervising the happy meal.

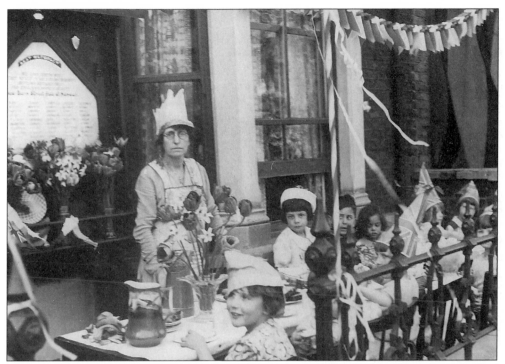

The next table in action with some smaller children. On the left is the New Barn Street Roll of Honour for those residents who lost their lives in the First World War.

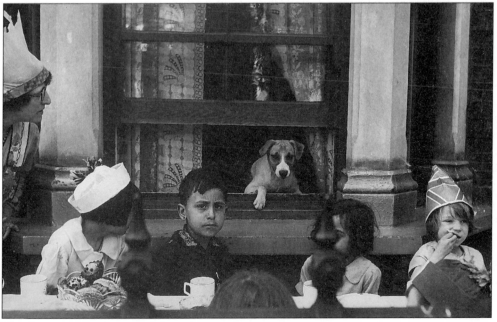

The dog was not going to be left out!

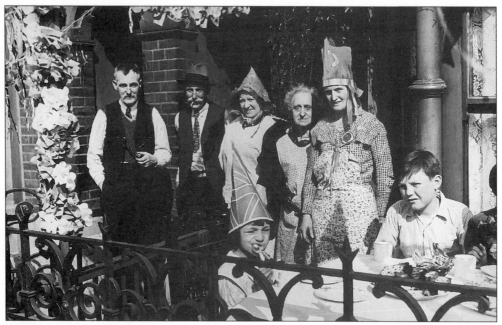

Neighbours with a family group.

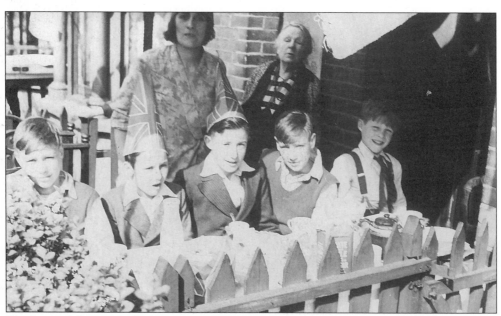

The boys celebrate together.

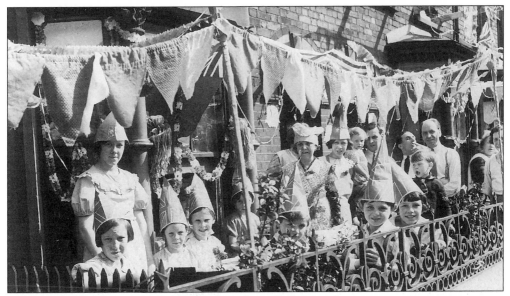

An extended family group a little way along the well decorated street.

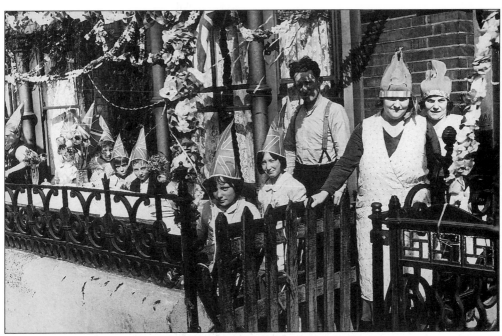

Another family group, well provided with patriotic hats.

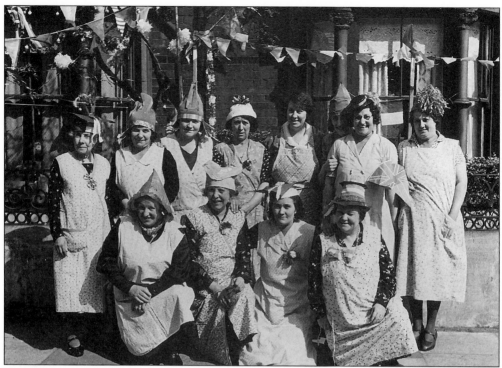

The ladies assembled for their group photograph. Clean pinafores were the favoured dress to wear while celebrating and serving food and drink to the children.

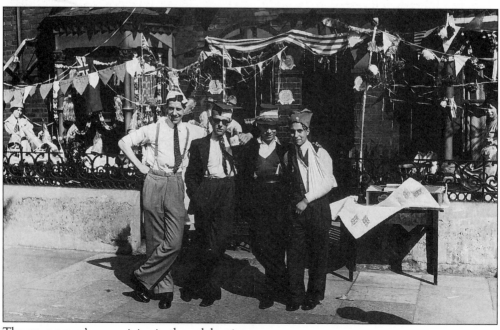

The young men's group joins in the celebrations.

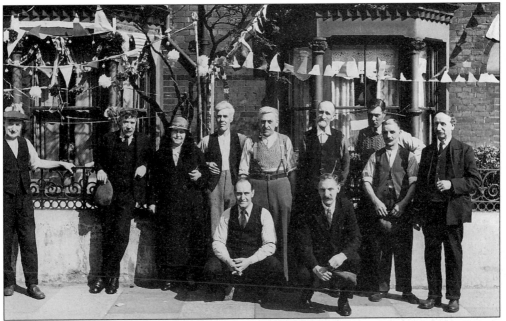

The men's group. My father is kneeling on the right hand side. Behind him is a retired sea captain who kept bulldogs which he took for walks along the street. Sometimes one would lie down outside our house and decide he would walk no further and would have to be carried home!

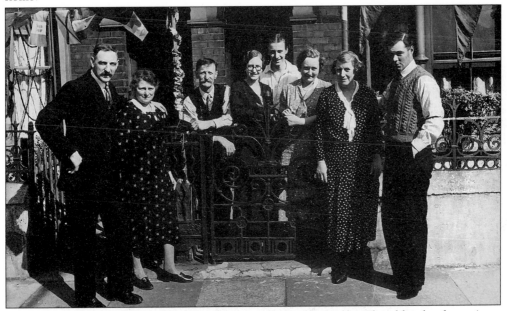

My parents are on the left with our neighbours the Seeley family. The elder daughter, Amy, went to school with my sister Elizabeth and is also in the 1912 photograph of the school choir. Her husband is on the right. Her younger sister, standing next to her, was the same age as me, and was apprenticed to the big drapers, Roberts at Stratford, receiving 2/6 per week 'and her tea' which was necessary because the shop was open until 8pm on weekdays, except Thursday, and 9pm on Saturdays.

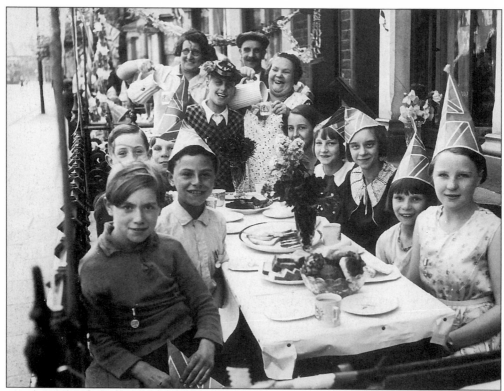

A tea party in progress on the north side of New Barn Street with Jubilee mugs being filled with tea by happy helpers.

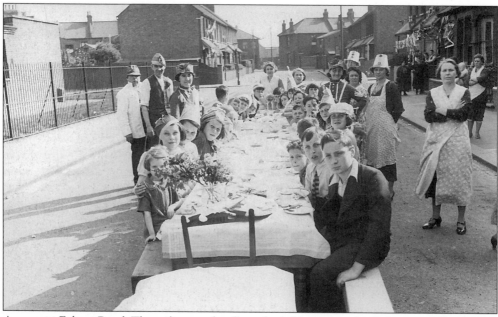

A party in Eclipse Road. The railings and wall on the left belong to the Relieving Office known as the 'R.O.' from which food tickets were issued.

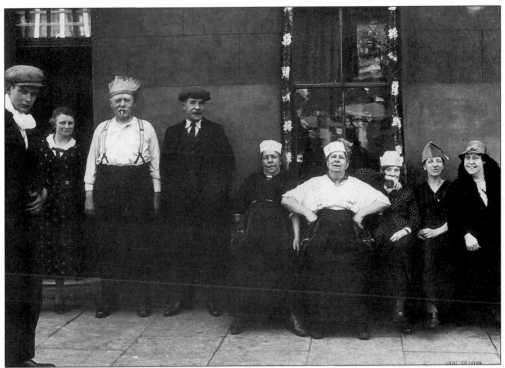

Members of the Lewis and Sims families at the corner of Denmark Street who ran the costermonger's barrow and donkey hire business. The commanding lady in the middle was graced with the name of Aunt Britannia. The smaller figure on the left is my mother who persuaded them to have a group photograph taken. From my earliest years I recall the sound of donkeys braying in Plaistow.

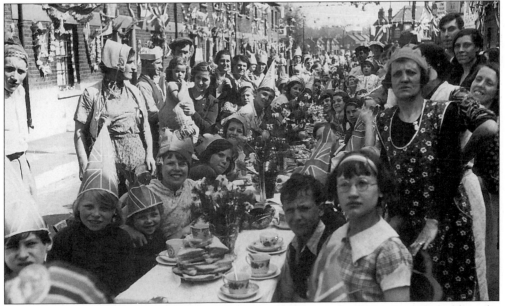

The celebration party further up Denmark Street looking south. I met the lady holding the child again at a reunion in 1987.

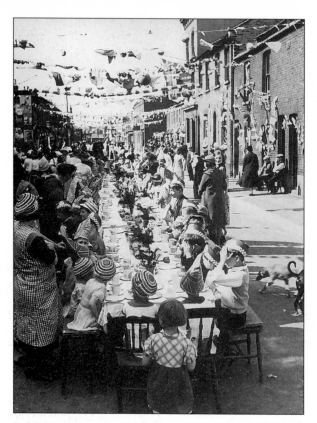

A large party in the middle of Denmark Street looking north. On the right in the middle distance is the off-licence of Mr and Miss Stiff who filled up the customers' jugs with beer and dispensed arrowroot biscuits for the children. In the 1930s period my Uncle George, who had been made redundant from the Docks, was taken on as an assistant.

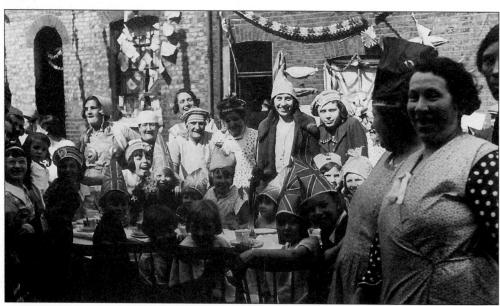

Some close-ups of a part of the Denmark Street celebrations.

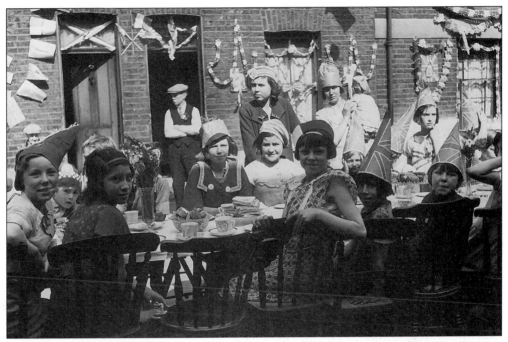

Another part of the side table.

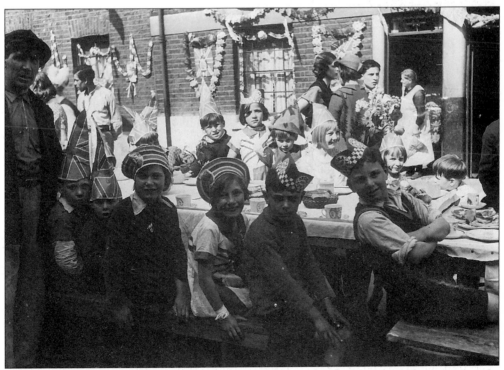

Not to be left out, the children leaned over backwards to be included! After all they all had the correct celebration headgear.

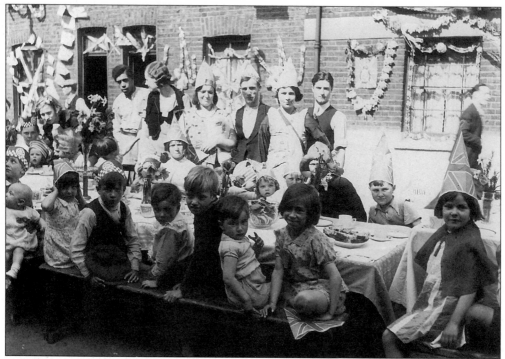

Even without hats, they wanted to be in the picture, especially as their dads had come out.

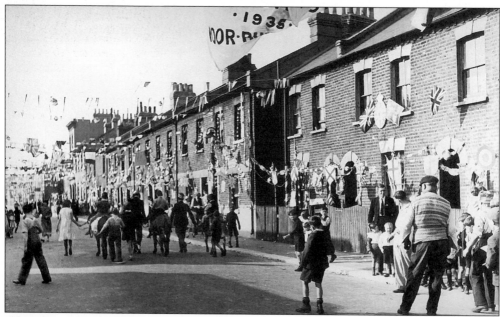

After the tables had been cleared away the fun began, with donkey rides provided for the children.

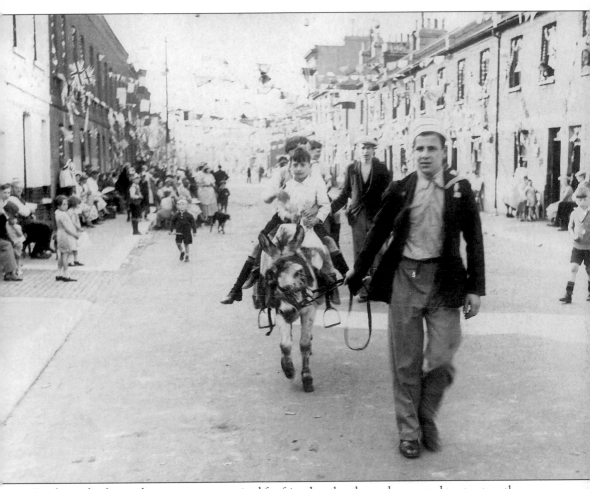

Donkey rides for tandem pairs were required for friends or brothers who wanted to stay together.

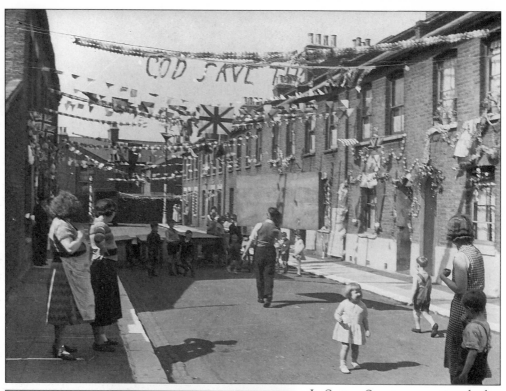

In Seaton Street preparations had been going on from early in the day.

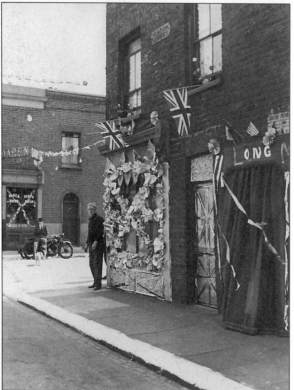

Mr Thurtle at the door of his greengrocers shop at the corner with Denmark Street. Opposite is the bakers shop.

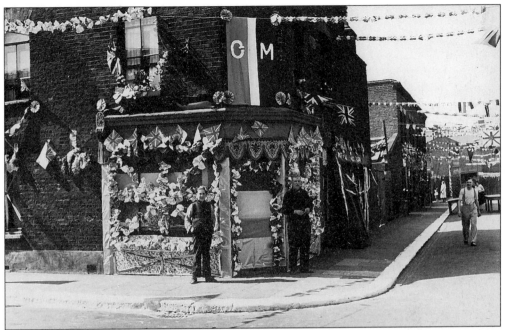

Mr Thurtle and his son with the shop well decorated for the event. At a much later date this photograph gave much comfort to the son who was seriously ill; he was surprised that the record of such a pleasurable occasion had been kept.

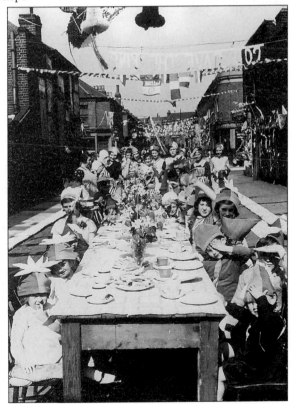

The Seaton Street party in full swing with 'God Save The King' and 'Welcome' banners to strangers coming in.

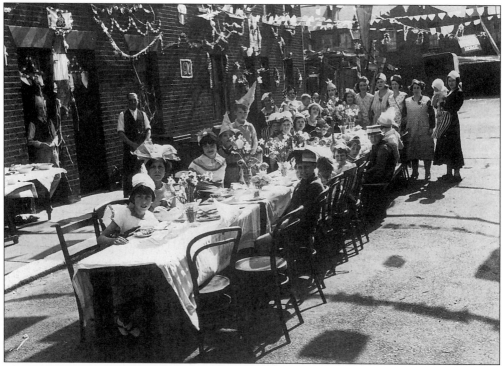

The Seaton Street west party with one of the 'Welcome Home' flags first used for the returning soldiers after the First World War.

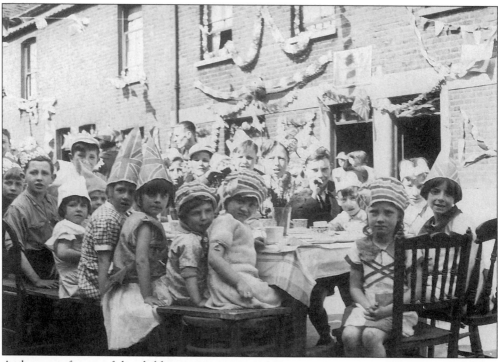

A close-up of some of the children.

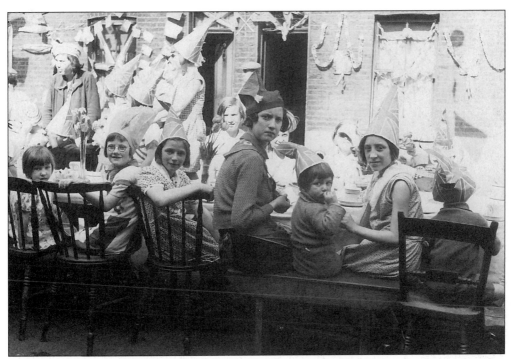

A close-up of children and a helper looking after the youngest ones.

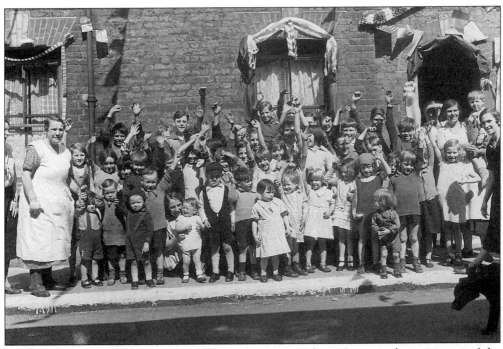

No shortage of children here! Even the very young ones have space to cheer or to cry if the event becomes too bewildering!

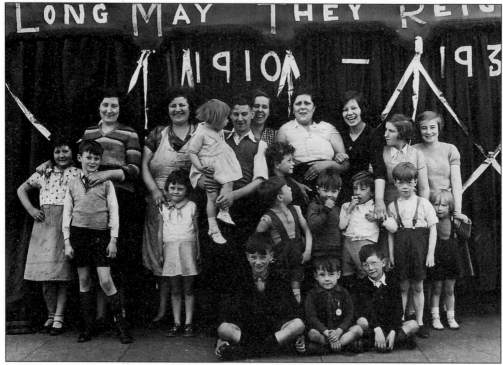

A group of families in Seaton Street with a well decorated background display.

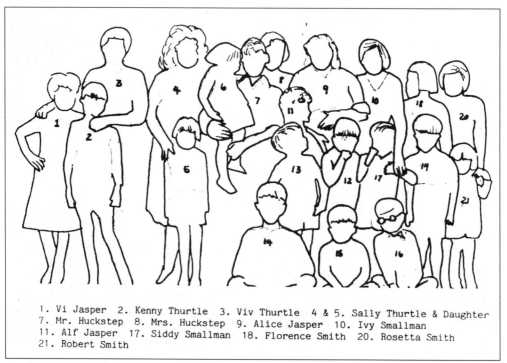

1. Vi Jasper 2. Kenny Thurtle 3. Viv Thurtle 4 & 5. Sally Thurtle & Daughter
7. Mr. Huckstep 8. Mrs. Huckstep 9. Alice Jasper 10. Ivy Smallman
11. Alf Jasper 17. Siddy Smallman 18. Florence Smith 20. Rosetta Smith
21. Robert Smith

A silhouette identifying everyone present in the above group.

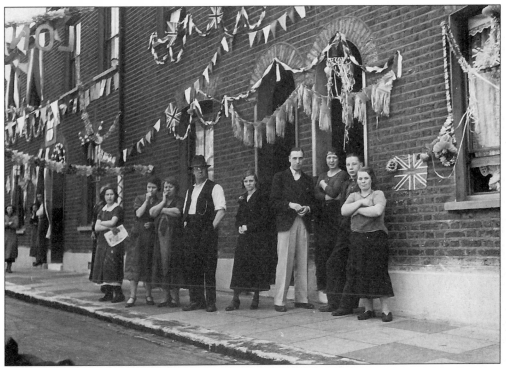

A group of residents in Seaton Street to the east side of Denmark Street.

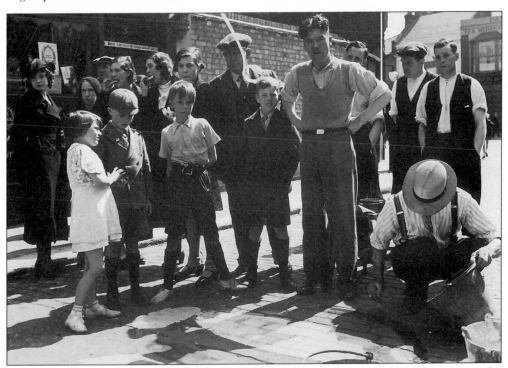

A street is being painted before an interested group. This is just off Barking Road near the Abbey Arms. Paske Farr, the grocers, is just in the background.

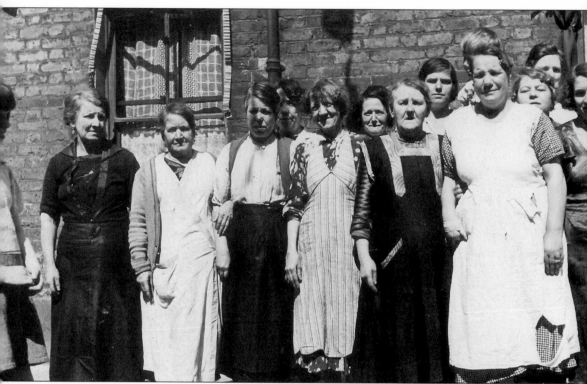

A group of women in Seaton Street east. In recent years I have met the daughter of Mrs Jarvey, fifth on the left. She kindly gave me the names of everyone in the group and a detailed account

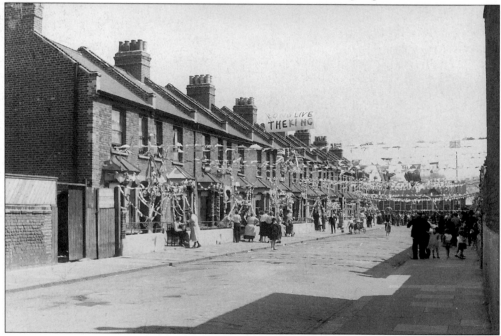

Avenons Road being decorated. In the background is Denmark Street school to which many of the children went from this part of Plaistow.

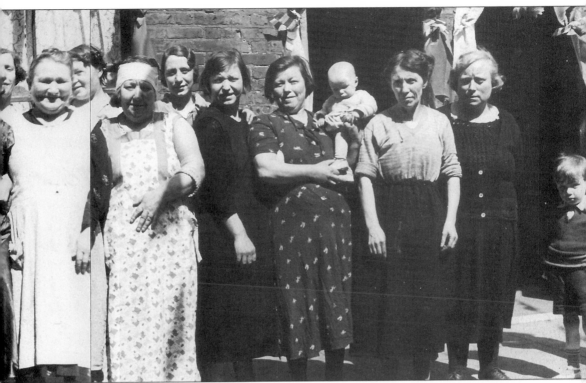

of the extreme poverty which is evident in this photograph. Mrs Jarvey was left a widow by the First World War.

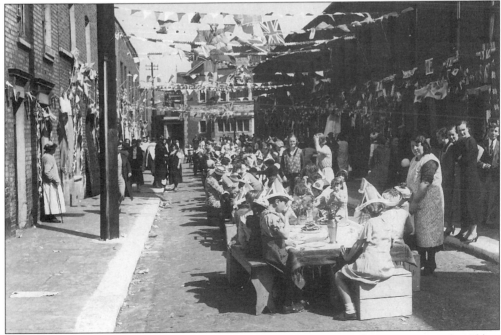

The tables are laid out and ready for the feast. This is in the Anne Street area near the Abbey Arms.

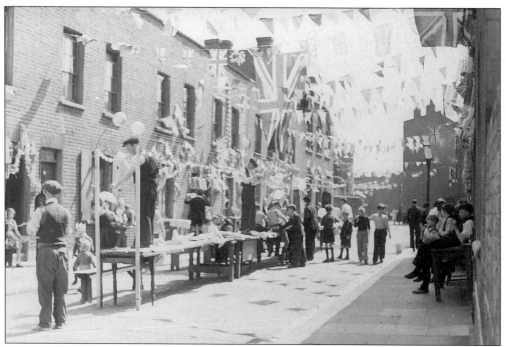

Tables being prepared.

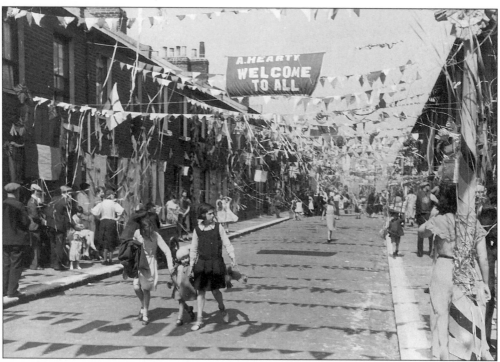

A profusion of decoration and a big 'Hearty Welcome to All' – they were obviously proud of this work and invited its inspection.

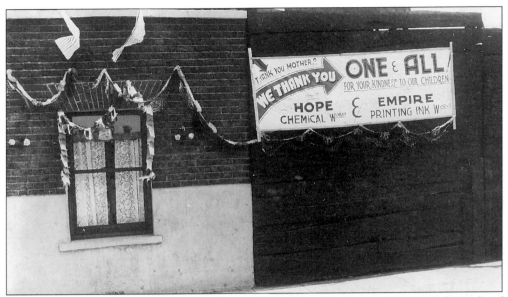

A note of appreciation from the Hope Chemical Works and the Empire Printing Ink Works of Anne Street and Chargeable Lane.

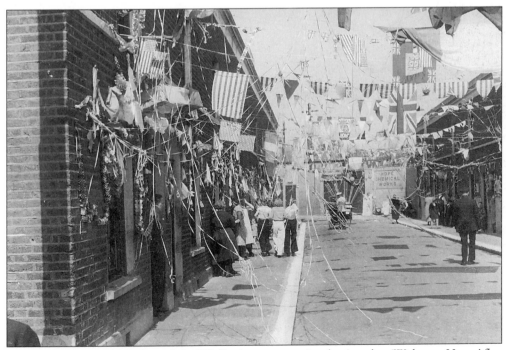

The Hope Chemical Works and the 'Wallsie' ice cream tricycle. Another 'Welcome Home' flag re-used from 1918.

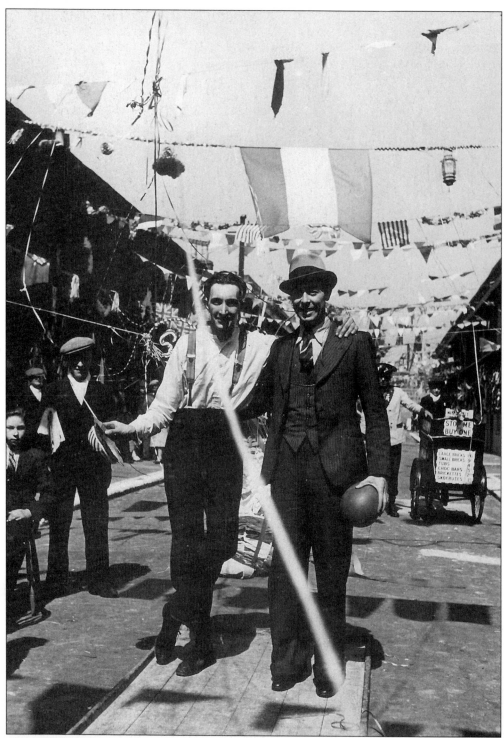

Along the road is a 'sand dance' performed by two bright residents while the Wallsie man comes up behind. A sprinkling of sand was made on the board to help the quick foot movements required.

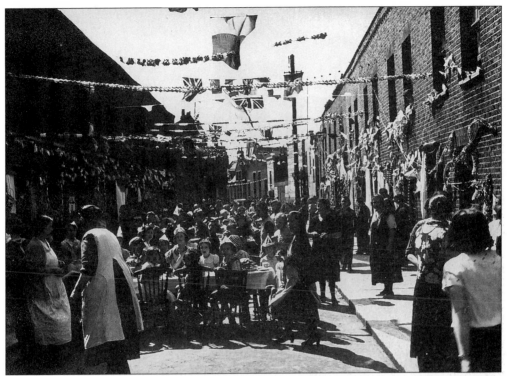

When I took this photograph there seemed to be a slight argument going on about the arrangement of the chairs or who was going to pour the tea!

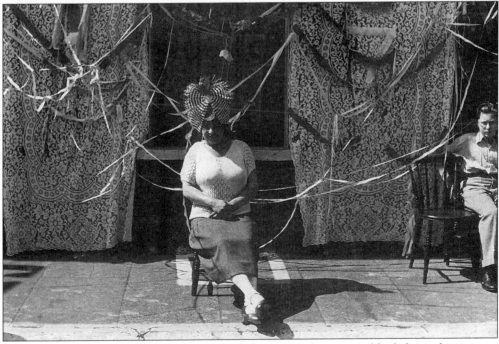

A photograph I have called 'The Queen of Sheba' with a disinterested look from who, appears to be, her son. It was a very good celebration set up whatever it was called.

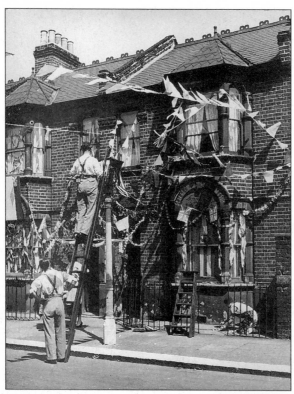

Cleaning up the front of the houses and decorating the lamp post in Cambus Road.

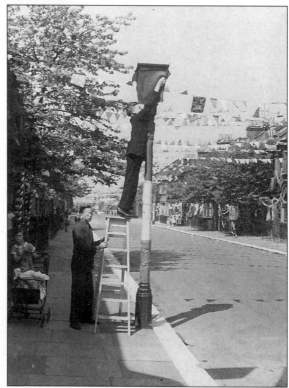

Another lamp post being decorated, a little precariously! and with a more general view of the road.

Two of the residents of Cambus Road decorating while two others show interest in what is going on.

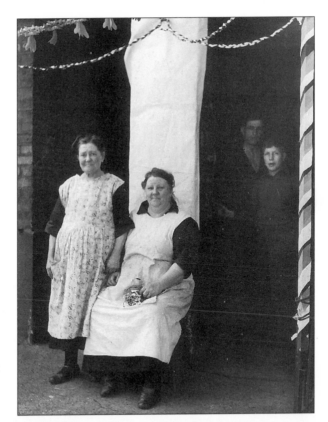

A family group in front of their decorated house also in Cambus Road. The tobacco advertisement is not a part of the scheme and the father of the family is finding it too hot for his collar and tie.

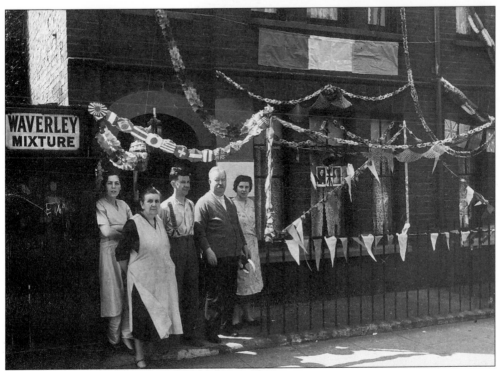

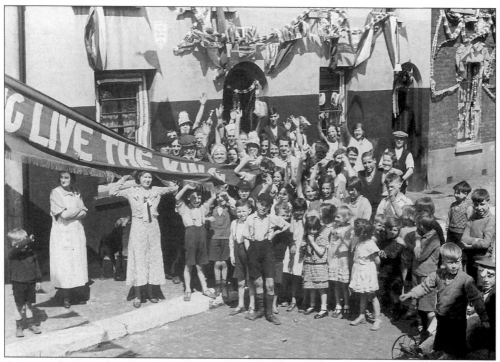

'Long Live The King'. A big supporting group at Nelson Street, Canning Town.

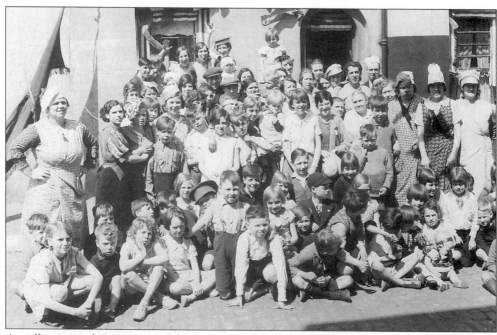

A well-organised group from Nelson Street. There was no difficulty in finding someone who would keep the kids in order.

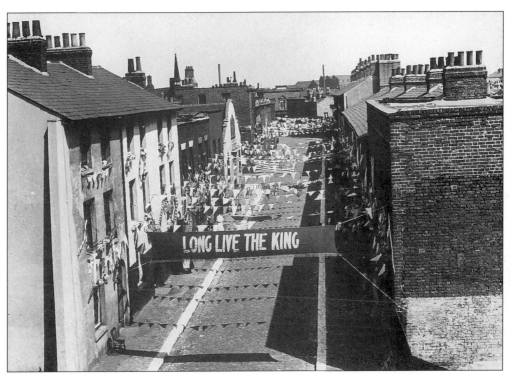

'Long Live The King' is safely hoisted and photographed from the newly-built Silvertown Way.

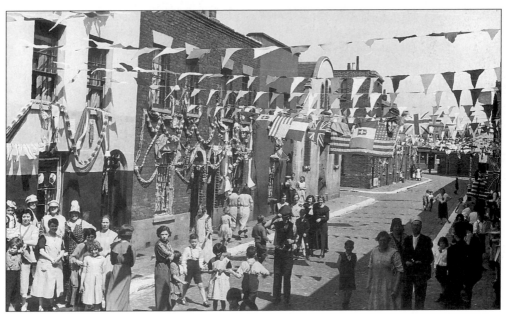

Nelson Street 'in repose'.

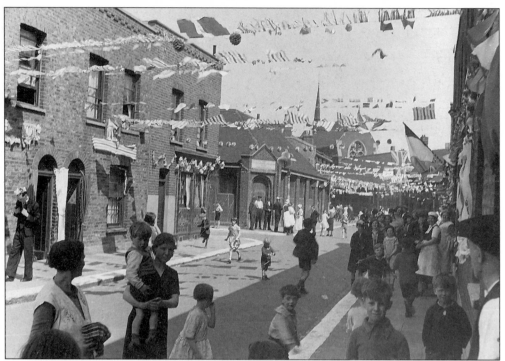

Hoy Street with St Luke's church in the background. The former pub, the Red Lion, is on the left corner with Emily Street.

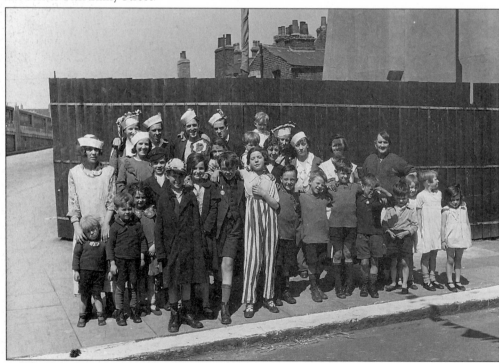

A Hoy Street group, from left to right: the families Dickle, Kelly, Bevan, Sibbons, Fitzgerald and Evans. I called this print 'Striped Pyjamas'.

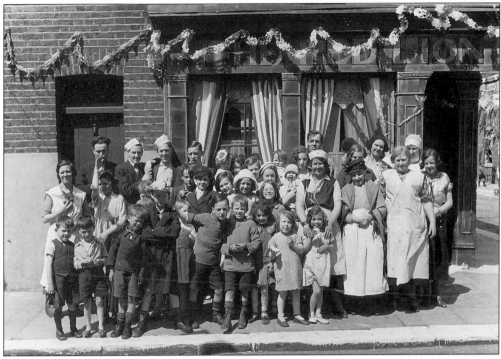

A Hoy Street group outside the old Red Lion.

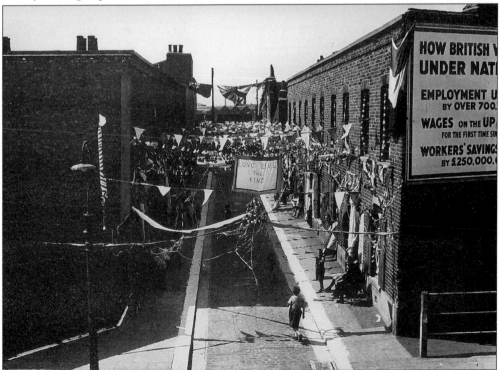

This is the western segment of Hoy Street from where the new Silvertown Way divided the original Hoy Street.

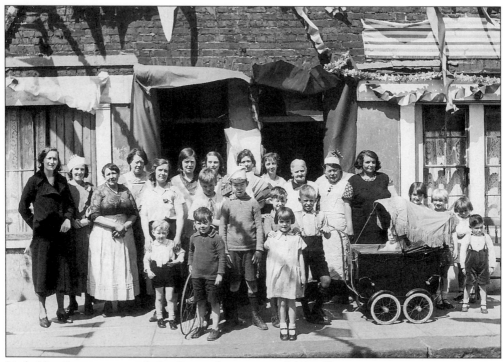

Little Hoy Street group with families as they were on Jubilee Day.

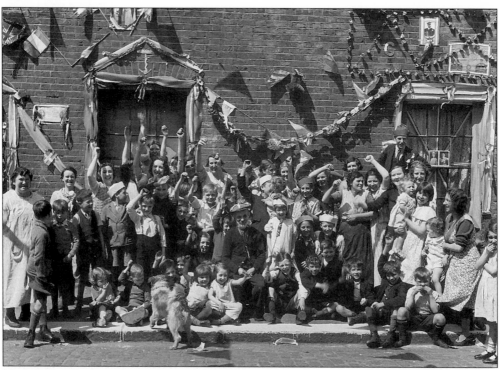

Huntingdon Street with grandpa and all the kids and the dog.

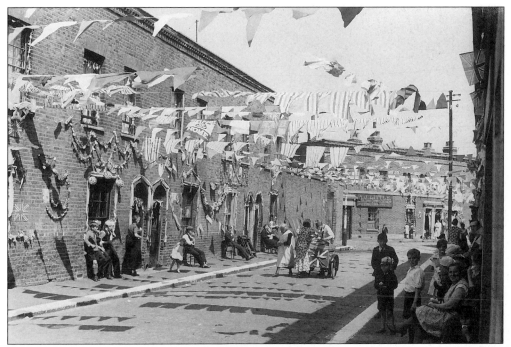

This is Huntingdon Street, showing the A.J. Little sign and the ice cream tricycle. Note the residents sitting outside enjoying the sunshine.

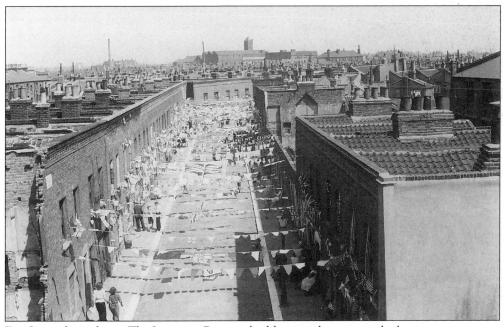

Fen Street from above. The Lampson Paragon building can be seen on the horizon.

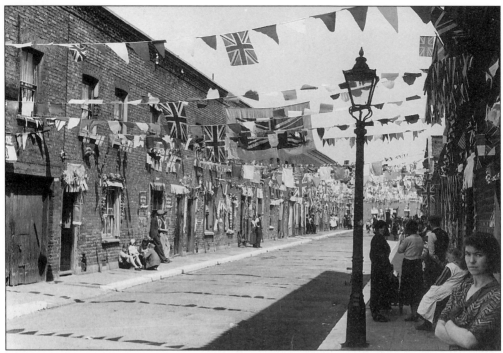

Fen Street from street level with the decorations now easier to appreciate.

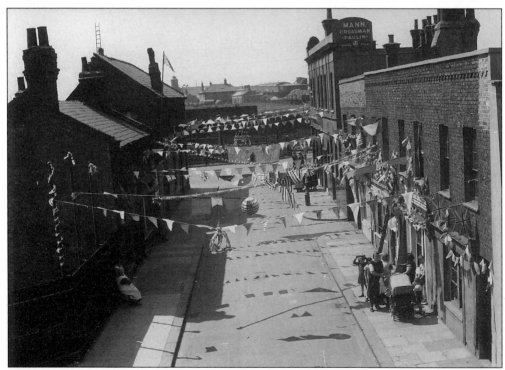

Another street which was divided by the Silvertown Way was Huntingdon Street. The bunting leads up to the pub.

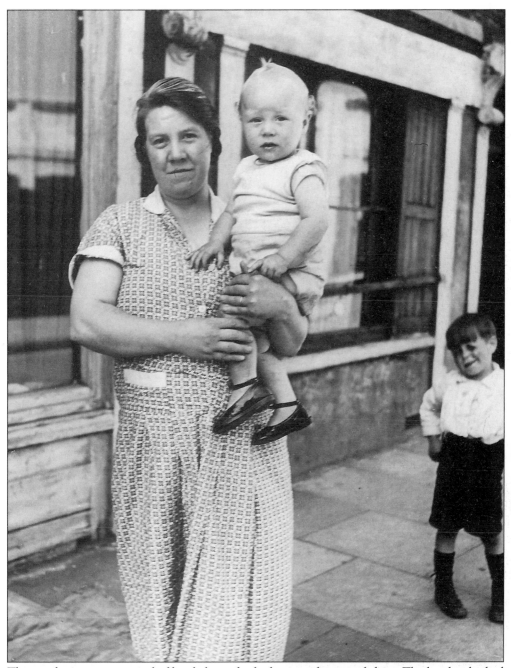

This mother was very proud of her baby and asked me to photograph him. The brother looked on. I eventually took other members of the family, convinced that none had seen a camera before.

This is the baby again.

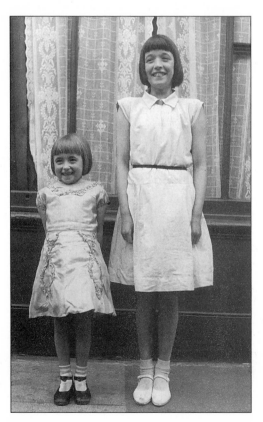

The two sisters of this family enjoying the occasion. I have always hoped that a member of the family would recognise their photographs but the area fared badly in the bombings of the Second World War. Perhaps this book will help.

Three
Re-union

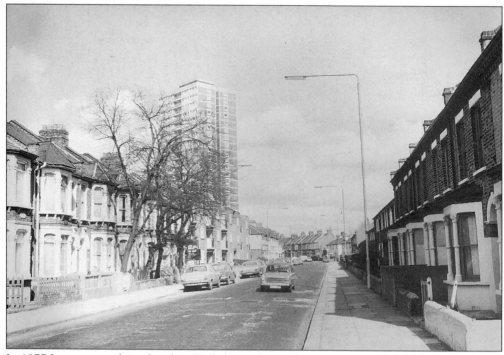

In 1977 I went to see how the place had changed over forty two years. This is New Barn Street with a tower block of flats in the background and a few trees but no iron railings.

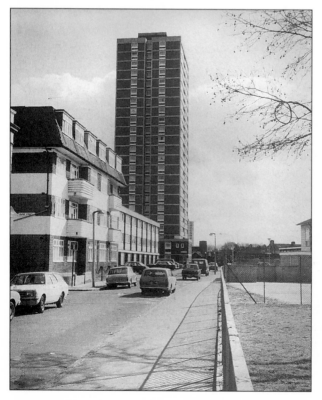

Denmark Street, renamed Jutland Road, and separated from the lower part of the original street at the junction with New Barn Street. Some residents or their children of Seaton Street were accommodated in the tower block flats.

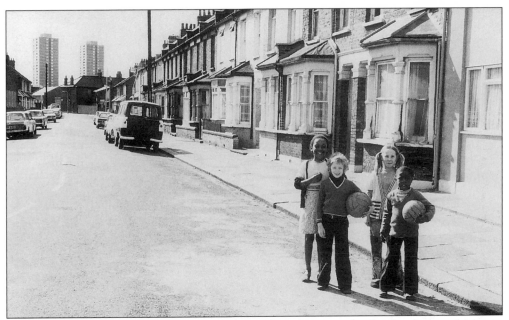

Children in Eclipse Road which had not changed much except for the first house which was rebuilt following war damage. The tower blocks in the background include the notorious Ronan Point in Butcher's Road.

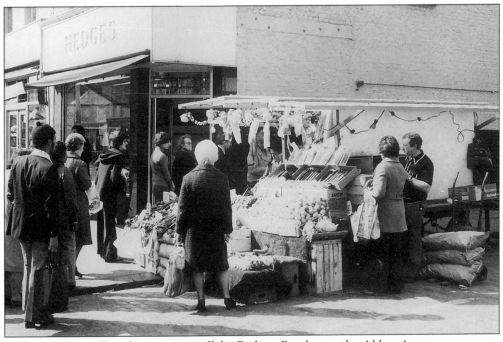

A greengrocers stall at the same site, off the Barking Road, near the Abbey Arms.

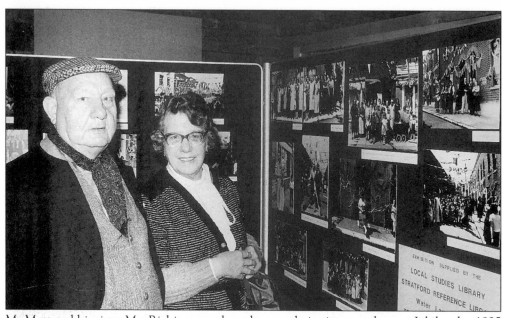

Mr Mott and his sister Mrs Richie were pleased to see their pictures taken on Jubilee day 1935 in Seaton Street. The exhibition was arranged by the Newham Local Studies Library.

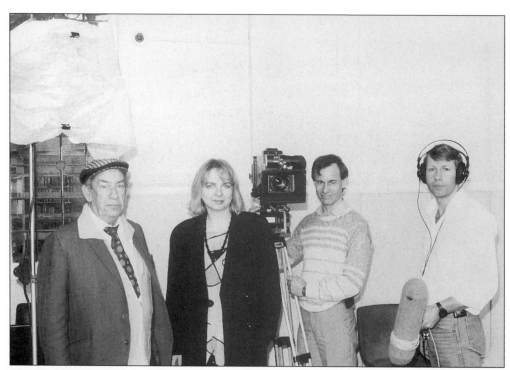

The BBC London television crew, with a visitor on the left, to record the exhibition of my prints of Plaistow and West Ham in the 1930s, arranged by the Local Studies Department at Custom House Library in 1988.

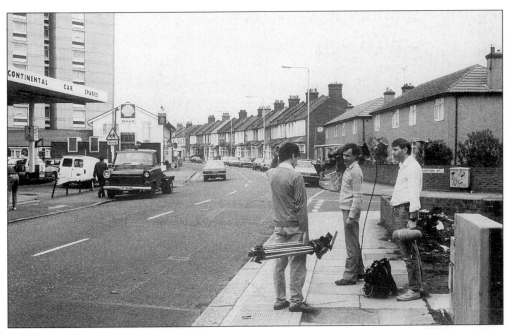

The television crew took me back to New Barn Street to describe what it was like living there in the 1930s and taking my photographs of the time with us. My old house at 109 and the shop next door had been destroyed in the war and used to be where the crew are standing.

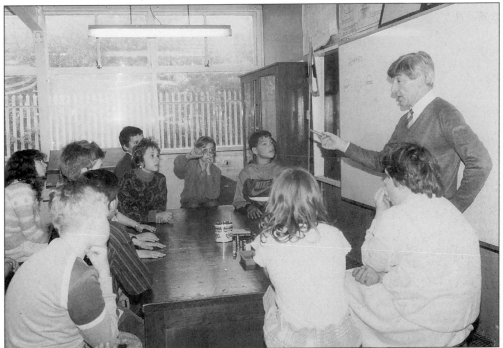

The television programme was put on at a popular time and was seen by the deputy headmistress of Cumberland School who invited me to give a slide talk at my old school, take photographs of classes in progress and join them on an outing to Docklands. This is a science class in progress.

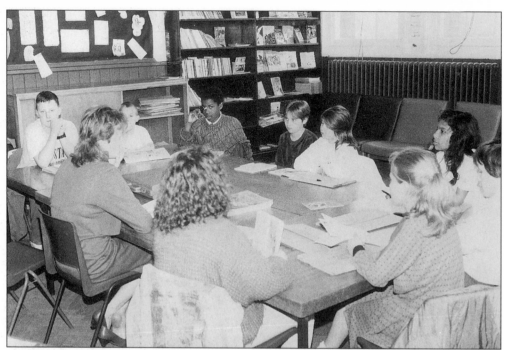

Another class, very different from my class of fifty seven pupils. Since my visit took place the school has been demolished and the site is now used for housing.

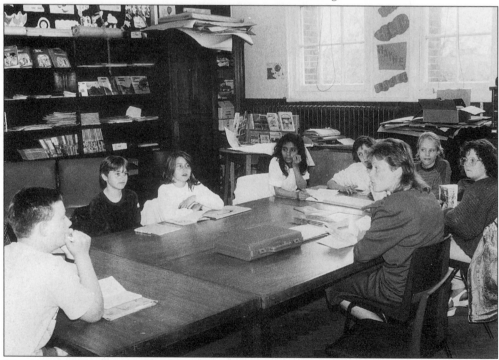

This scene with books and papers shows a more friendly class than those of my days. After my visit I received a large pack of individual letters thanking me for my talk and for joining in their work which I much appreciated.

A close-up of scholars listening to the account of the Dockland plan.

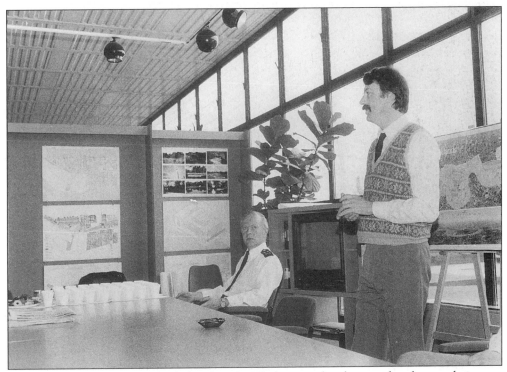

The lecturer showing, with the help of maps and photographs, the way the plan was being put into effect.

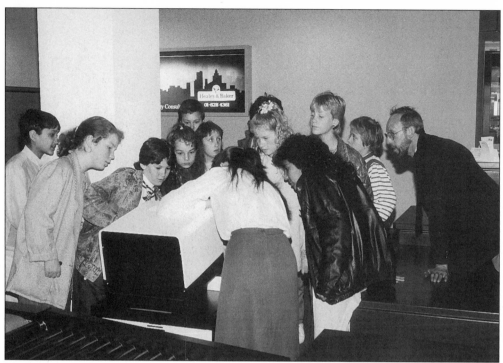

The class being shown the arrangements at the City Airport for controlling the input of luggage. The coach driver on the right is also interested.

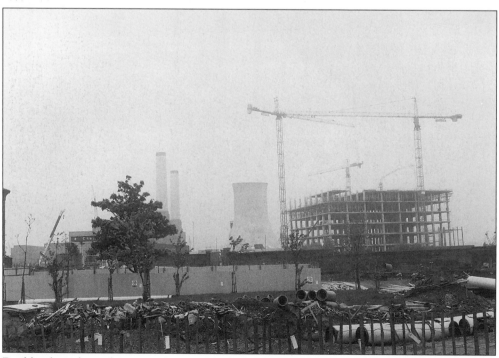

Docklands in the early stages of construction and seen by the class from Cumberland School.

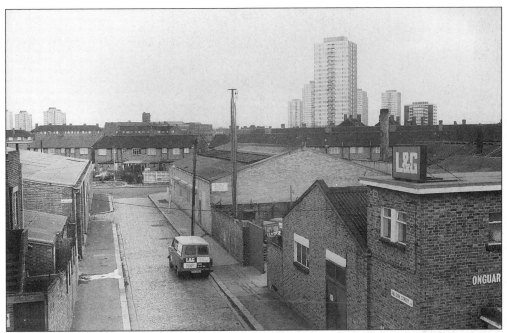

Nelson Street in 1977. All the houses standing in 1935 had gone and industrial premises had been set up.

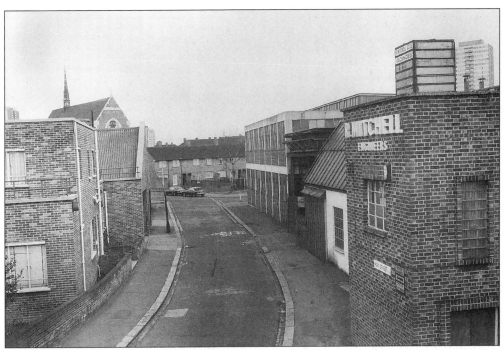

Hoy Street in 1977 with an engineering works in the right. St Luke's Church is the only land mark from the earlier days.

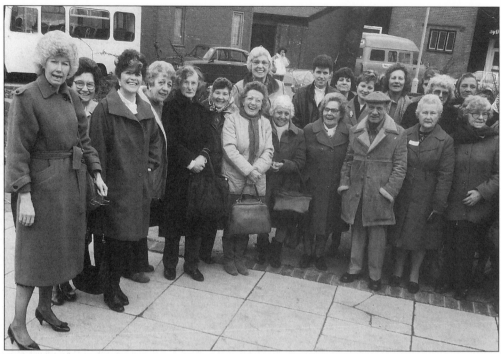

We had many letters and messages of appreciation for the exhibition of the 1935 Jubilee photographs. Howard Bloch, the Local Studies Librarian had the bright idea of inviting the correspondents to a reunion at the Mayflower Centre in 1987.

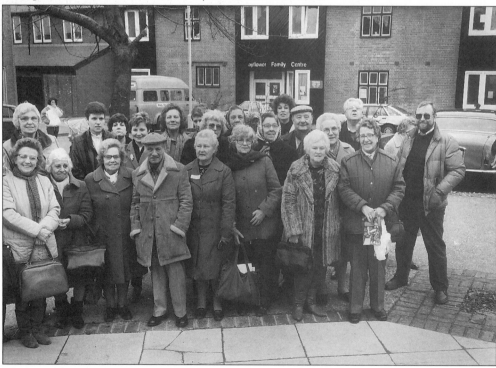

Many people turned up for the event, hence the extra photograph to get them all in!

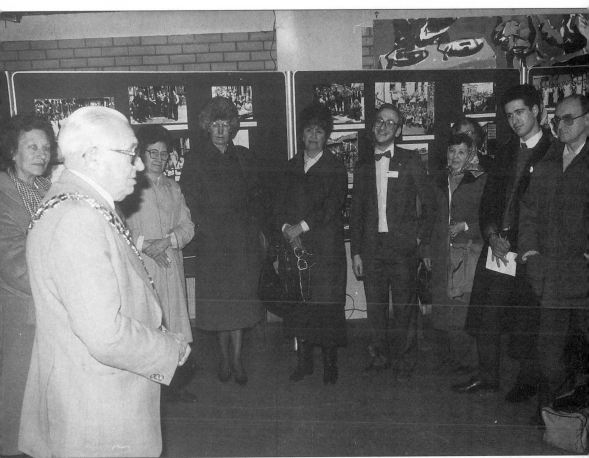

The Mayor of Newham attended to welcome the old residents and to open the exhibition of the 1935 photographs. This site was known as the Dockland Settlement in the pre-war days.

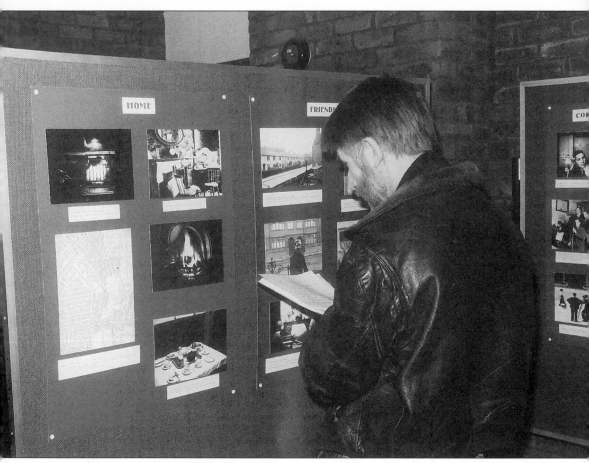

An exhibition at the St Bartholomew's Community Centre near the East Ham Town Hall giving a more general series of photographs in the 1930s which I illustrated with a slide talk. Mr Marriott is examining the prints.

Four

Out from Plaistow

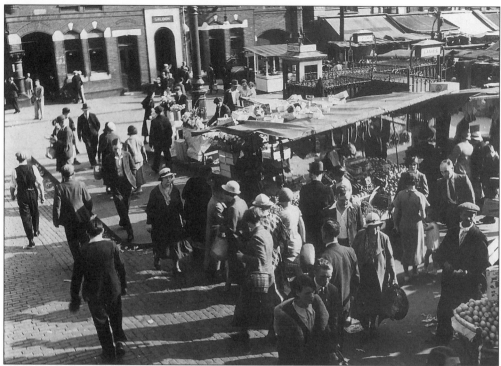

Queen's Road market off Green Street, by the bus stop for Upton Park station. Relatives of the people in the photograph have been pleasantly surprised to spot them at an exhibition. This part has now been built over.

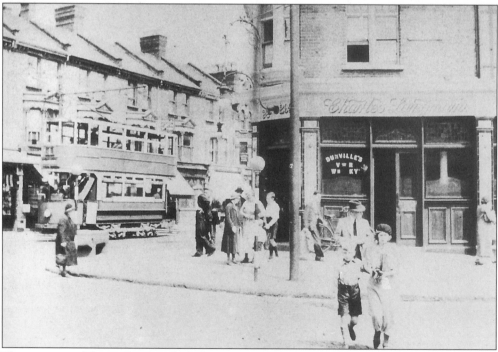

The junction of Green Street and Plashet Grove in 1935. Note the tram and the horse trough.

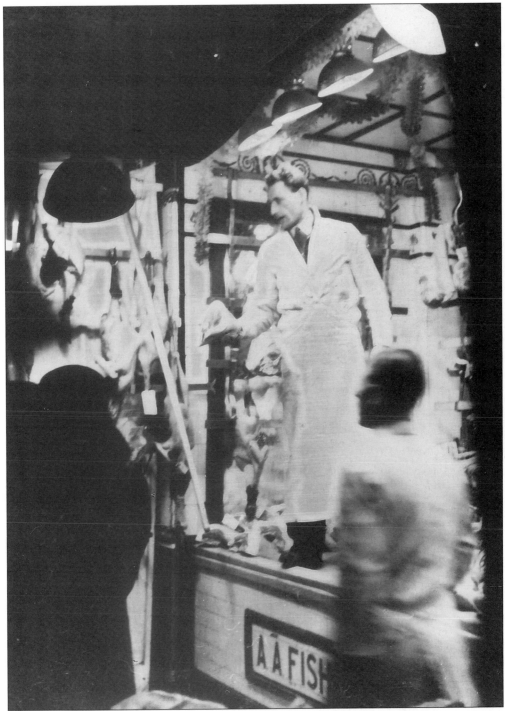

Auction of meat from the shop of A.A. Fish, near to the 'Boleyn', on a Saturday evening in 1934.

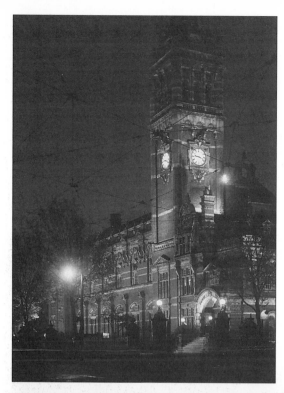

East Ham Town Hall the first time it was floodlit in 1934. One could set up a camera on a tripod in the middle of the Barking Road in those days!

My friend Francis and his bride Rose, who were both teachers at the Socialist Sunday School, being celebrated on the occasion of their marriage in 1936.

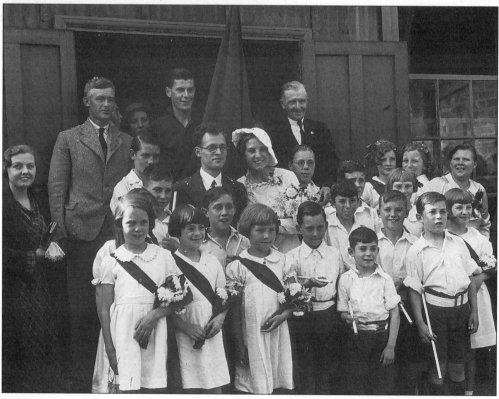

The hat shop in High Street North, East Ham when 'film stars set the fashion'.

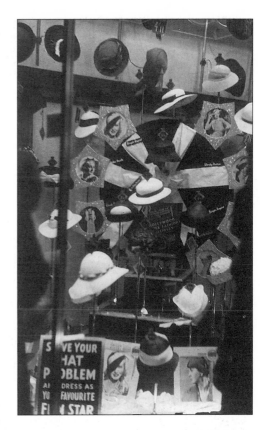

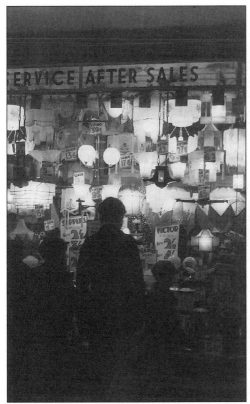

The window of the electric fittings showroom in High Street North. The shops were becoming interested in stocking wireless components and you could buy transformers and valves in 1935.

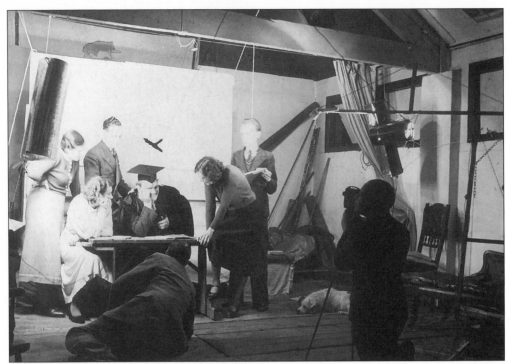

The West Essex Film Society at work above garages off High Street North. It had members mainly from Plaistow and had a good welcome at the Granada cinema, Barking Road, by Mr Bernstein even before he became such a well-known magnate!

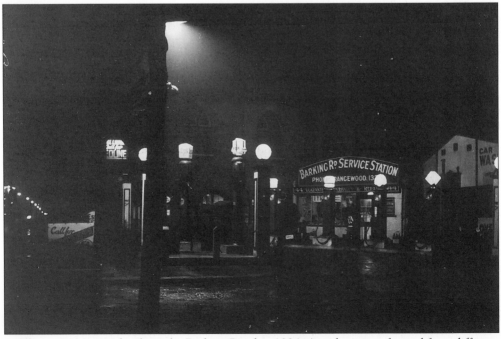

A filling station at night along the Barking Road in 1934. A wide range of petrol from different suppliers was available at that time from the one filling station.

The Coliseum picture palace in the Romford Road which was typical of many local cinemas of the time. There were two brightly uniformed attendants, Western Electric sound system and a neon display.

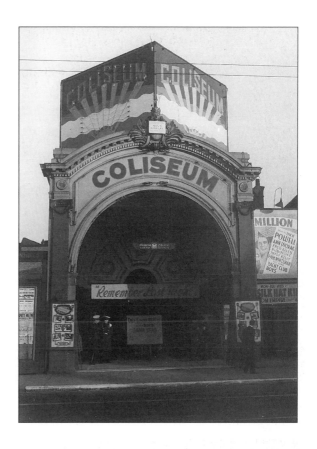

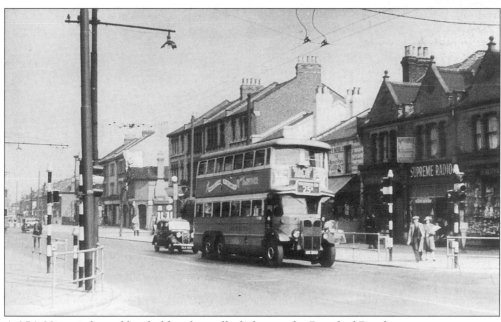

A 25A Victoria bound bus held up by traffic lights on the Romford Road.

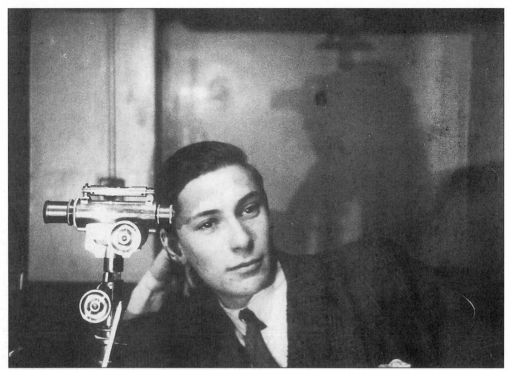

My fellow student, Lawrence Bull, in the laboratory at the West Ham Municipal College in 1933.

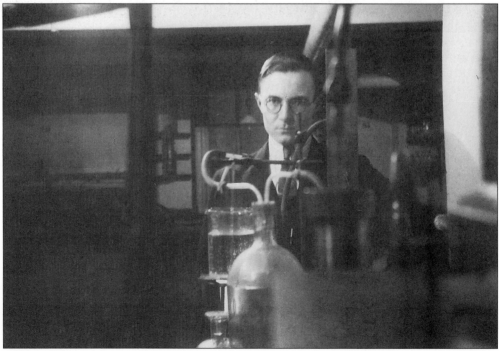

Another fellow student with a more complicated assembly of equipment.

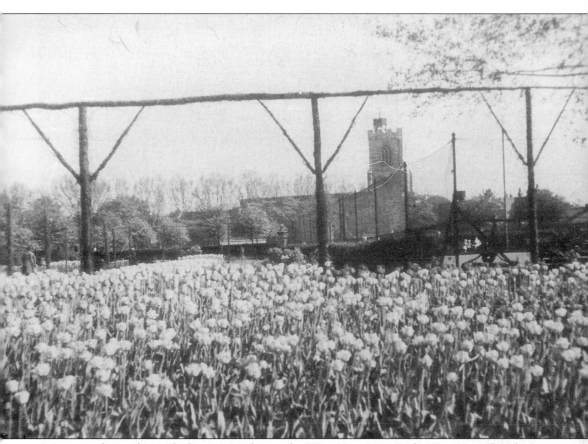

A scene in the garden with the spring tulips at the West Ham Lane Park. West Ham church is in the background and I remember scrambling up the narrow stairway to the top during a lunch break at the secondary school.

Silvertown Way nears completion in 1935.

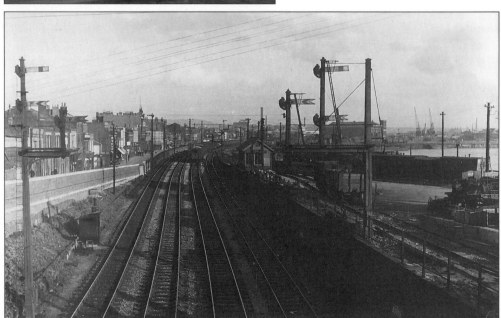

The scene from Canning Town station bridge with 'The Marsh' on the left and the River Lee on the right. When I was very young I recall seeing the fire engines coming out for a call to go along 'The Marsh'. They were pulled by excited horses towing a steam pump blowing out black smoke!

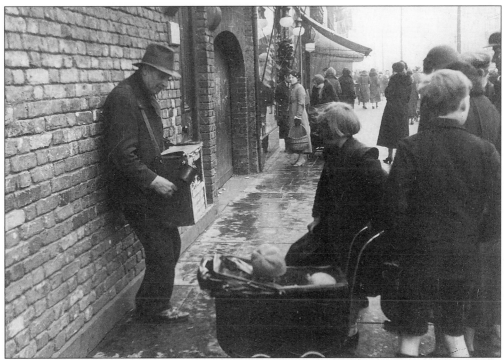

A hurdy-gurdy man on the Barking Road near Trinity church in 1935.

Holy Trinity church, Canning
Town with a point duty policeman
on duty at the junction with
Hermit Road. I was christened here
in 1913 but it was badly damaged
during the Second World War and
not rebuilt. The bells were saved
for St Paul's, Harlow. The men are
waiting outside the employment
exchange.

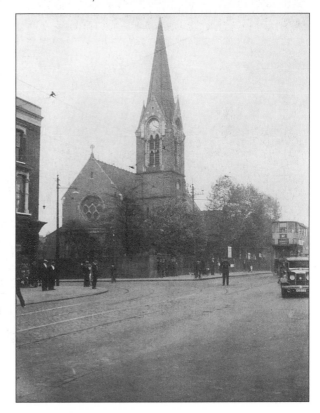

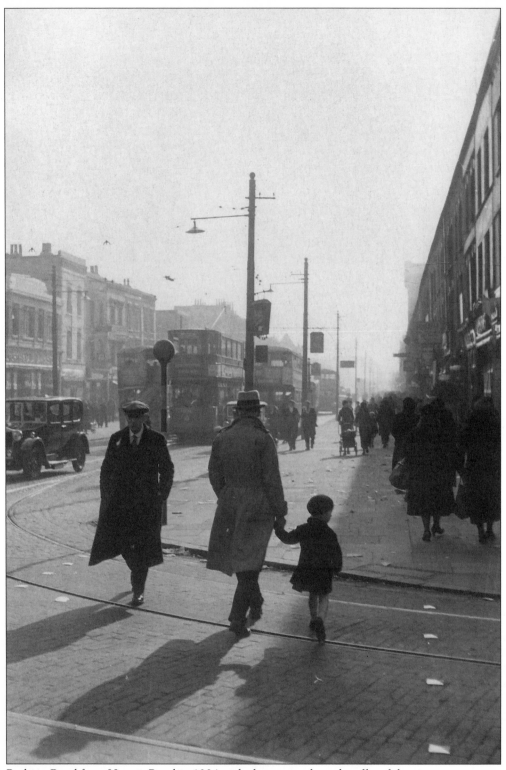

Barking Road from Hermit Road in 1934 with shops, people and traffic of the times.

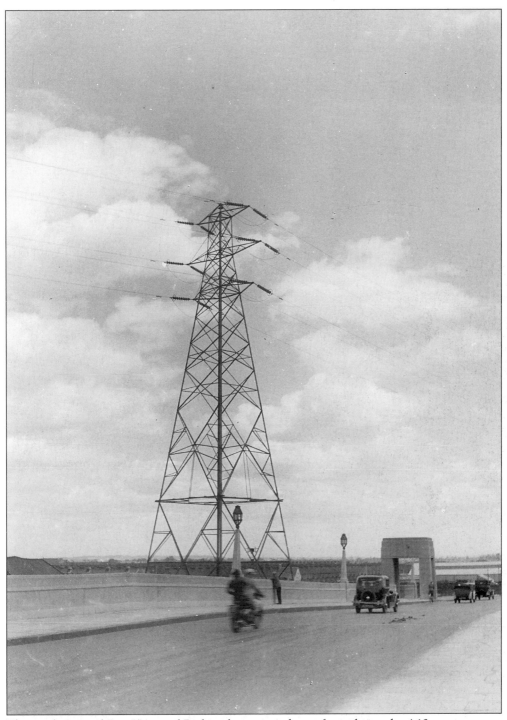

The newly opened East Ham and Barking by-pass road transformed into the A13.

Usk Street, Canning Town from Silvertown Way in 1935. Although people here are getting some sunshine there is a haze of smoke from domestic chimneys.

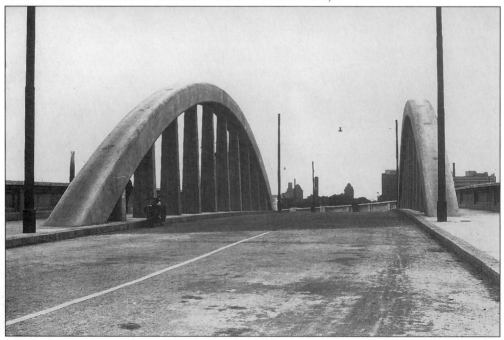

The bridge of Silvertown Way in 1934. On this day I was on a trip on the motorcycle and was using infra-red plates in my camera. This shot was taken with one of them but no filter was used.

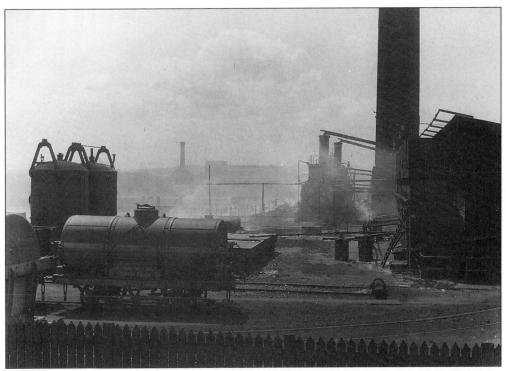

The factories at Silvertown. The tanker is marked 'Gas Light and Coke Company, Beckton, Essex'.

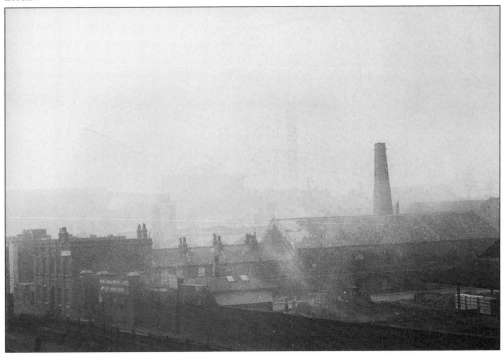

Another part of the factories site on a misty day. This was the usual look about the place, particularly if there was not much wind.

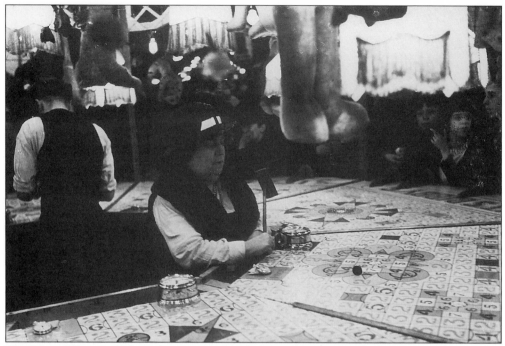

The fair at Wanstead Flats where many people went during Bank Holidays. At this stall you could literally throw your pennies away; one is seen in motion! Coins had to be clear of the line when they toppled over to win, which was very difficult to do.

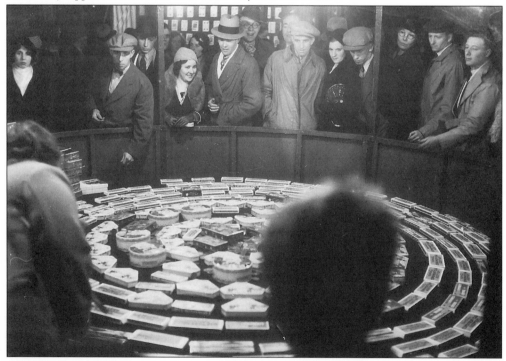

An older form of the Hoop-la! Given a small hoop you had to throw it to cover a prize to win. The interest and dress of the players can be appreciated in this shot.

Five

To the Docks, River and Woolwich

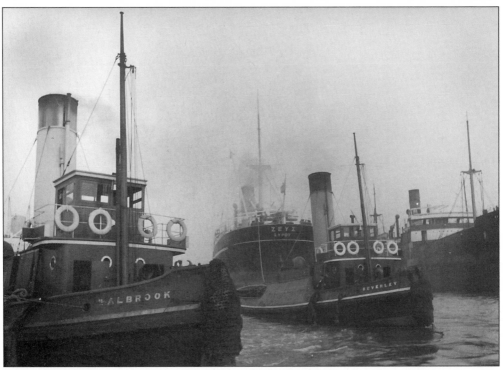

The tugs *Walbrock* and *Beverley* in King George V Dock, 1934.

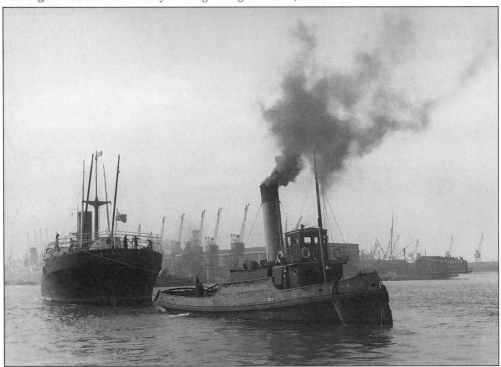

A tug working on the *Romsey*. The swing bridge has been opened, closing the entrance to the centre part of the dock.

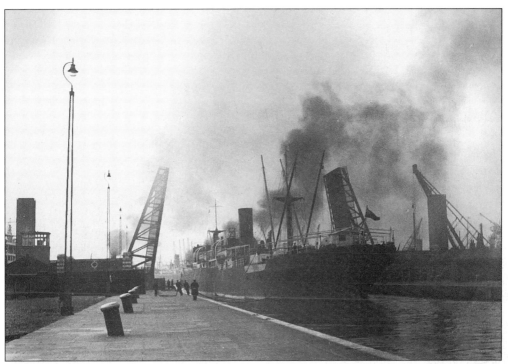

A ship going through the cantilever bridge and the lock.

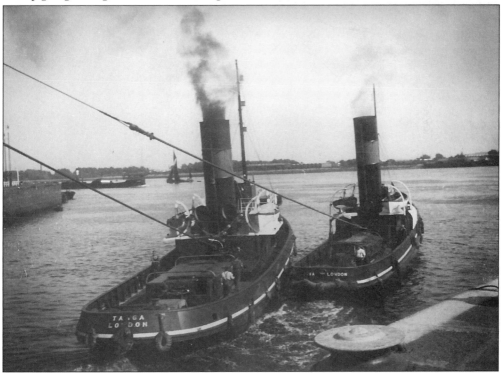

Tugs preparing to pull a ship into the river. There is a Thames sailing barge going down the river and a river vessel coming up.

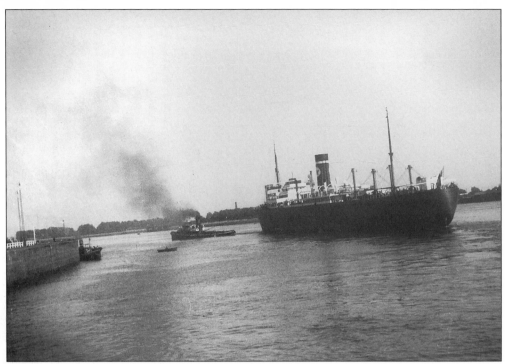

A Blue Star ship being pulled into the river channel.

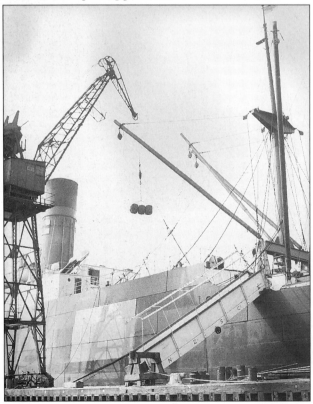

The New Zealand Shipping Line *Port Pirie* unloading in the dock.

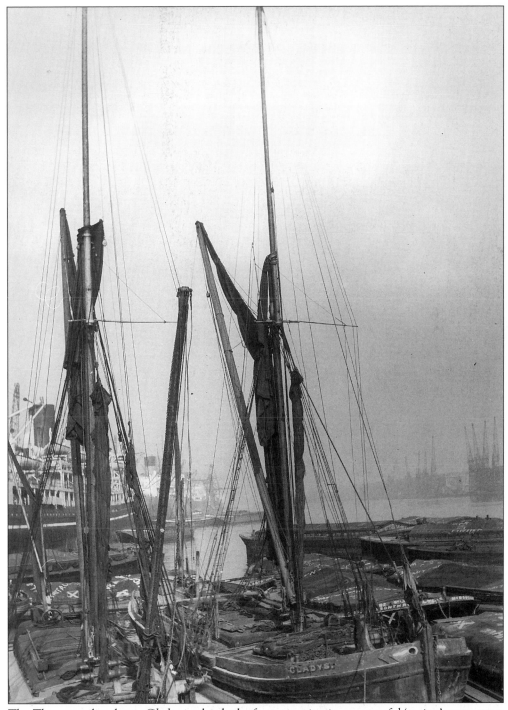

The Thames sailing barge *Gladys* in the dock after appearing in a successful 'acting' programme c. 1934.

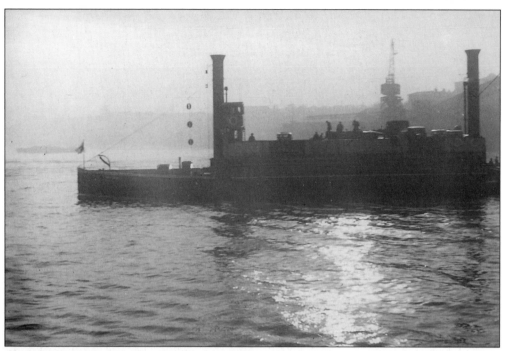

The *John Benn* Woolwich Ferry drawing away from the south pontoon, 1934.

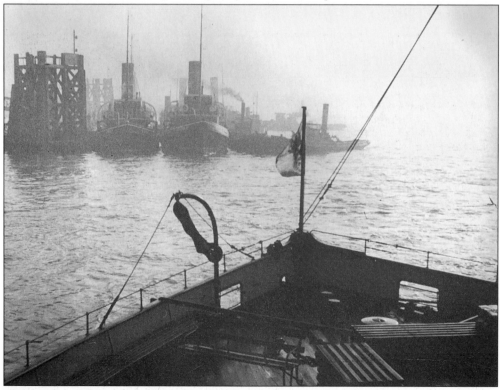

The Woolwich Ferry boat near the L.N.E.R. pier at North Woolwich where the tugs were moored unless the pier was being used for larger vessels, 1934.

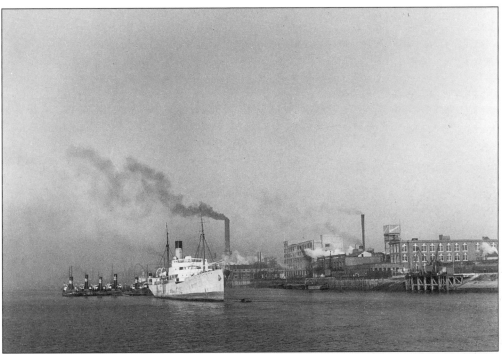

The Standard works and the imposing Tate smokestack seen from the Thames and looking north-west from the ferry.

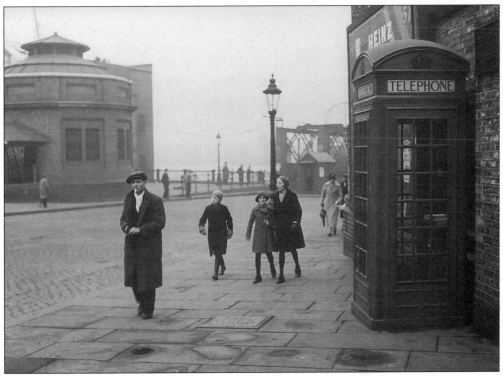

Foot passengers coming off the Woolwich ferry at the south pier in 1934.

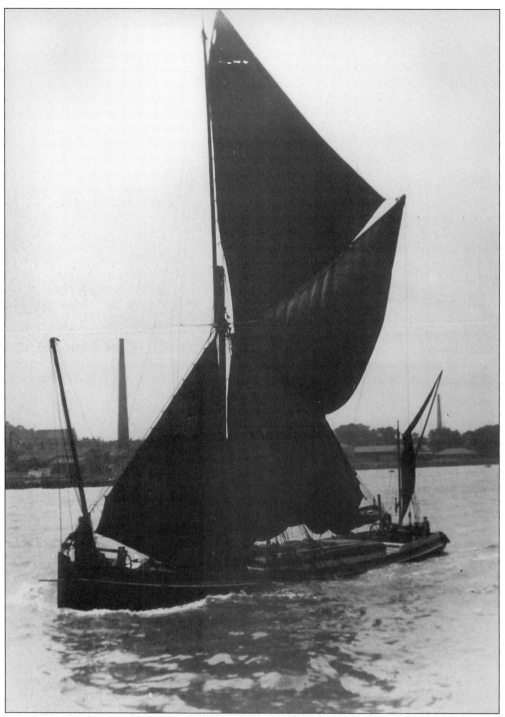

The *Edith May* Thames sailing barge was usually in the charge of a master and a strong lad! This photograph has the south Woolwich shore as a background.

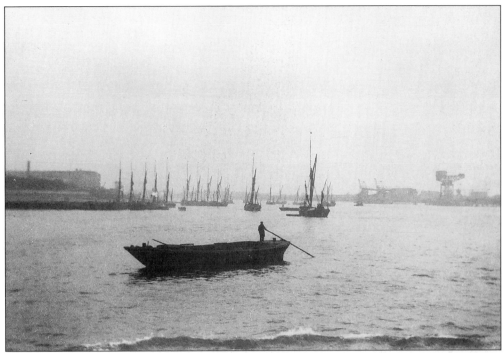

A dumb barge in the charge of one man and a long sweep. In the background are more Thames sailing barges, most of them being or about to be laid up. The big crane in the Royal Arsenal is dominant on the horizon.

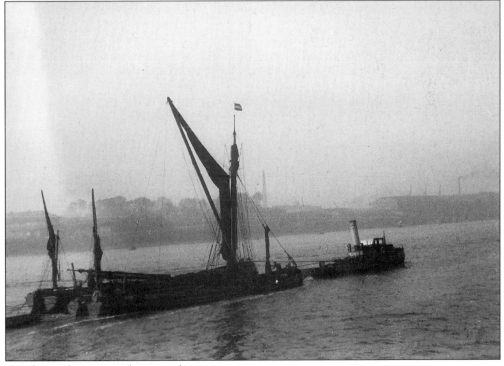

Two barges being towed up river by a tug.

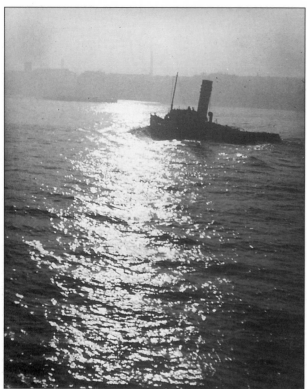

A tug proceeding down river photographed from the Woolwich ferry.

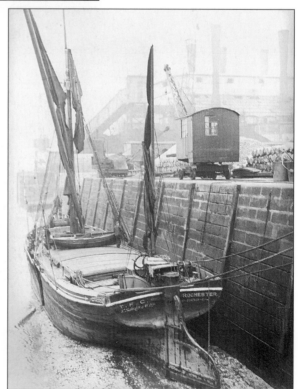

A Thames sailing barge from Rochester on the Medway berthed to load and unload on the wharf at South Woolwich. I have travelled to Rochester from the Thames in a very small boat and it took nearly a week!

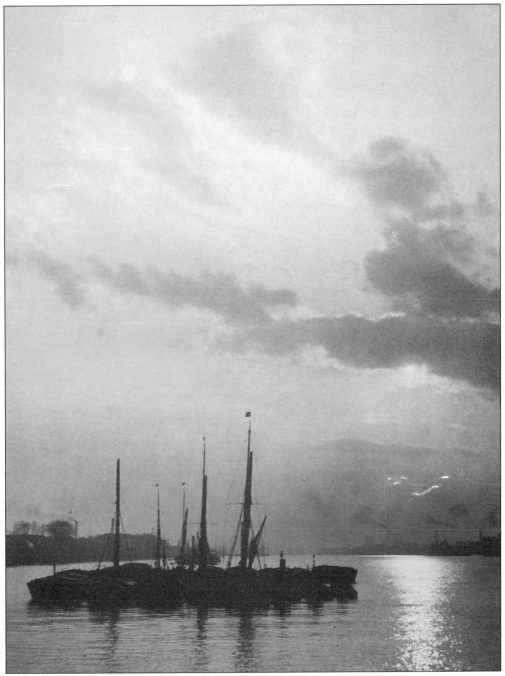

An evening view up-river from the Woolwich ferry with sailing barges in the foreground.

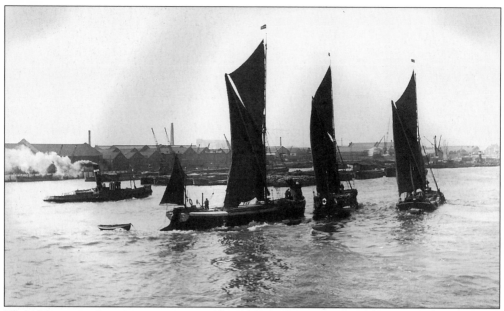

Three Thames sailings barges appearing to be in friendly competition going up river off Millwall wharf.

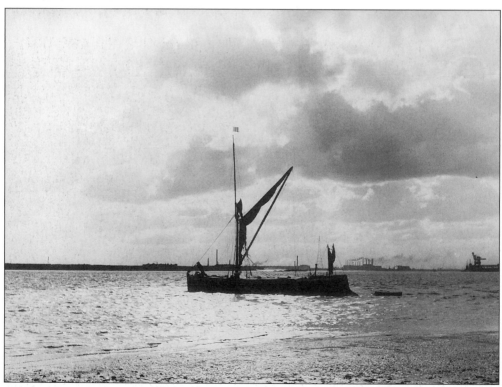

A sailing barge anchored on the shore waiting for the turn of the tide. The Ford works is in the far distance.

During the 1930s a fleet of 'Eagle' class paddle pleasure steamers went down the Thames to Southend and other parts such as at Clacton and Margate for day trips. This photograph was taken off Woolwich on the *Royal Eagle*.

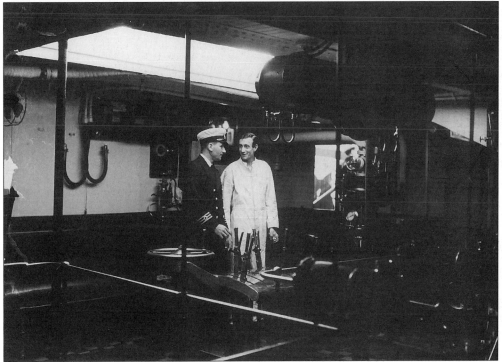

In the engine room of the *Royal Eagle* in 1935.

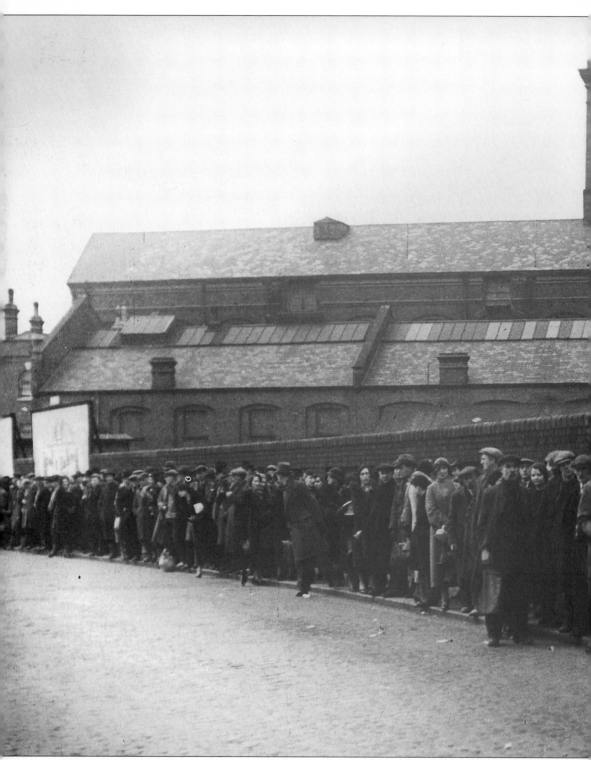

When the 'bridgers' were operating at the docks the No. 101 buses were held up and a long queue built up at the terminus point just off the Woolwich ferry and tunnel, north side. One of

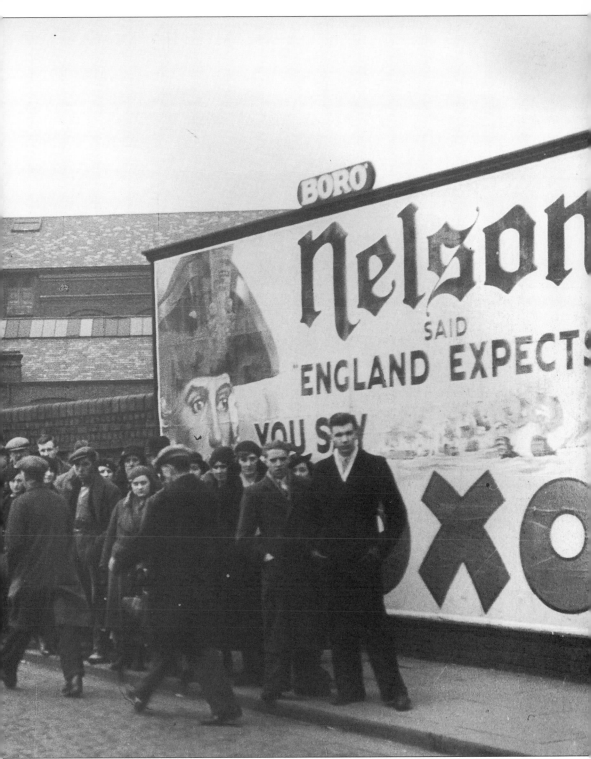

my audience at at slide show said 'I was in that queue but round the corner out of sight!'

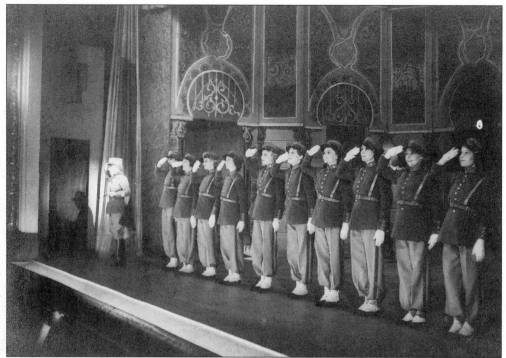

I was given any seat in the house to photograph scenes from a live professional show, in this case the *Desert Song* musical. This was at the splendid Royal Artillery Theatre in Woolwich on the parade ground precinct. Unfortunately it was destroyed by an air-raid during the war and not rebuilt.

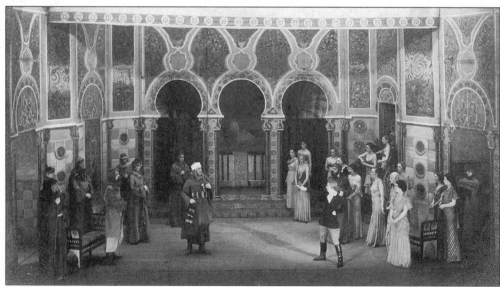

Another scene full of artistes in action! The public were allowed to attend these shows and on the occasions when I was there they were well attended by enthusiastic audiences.

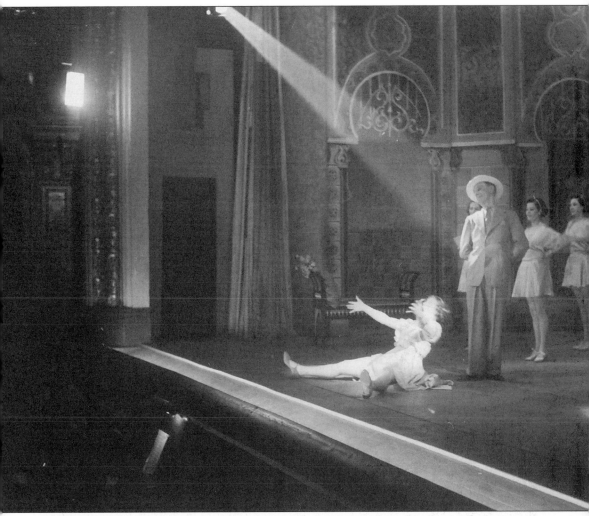

A different angle shot from a box close to the stage. I took the these photographs for the benefit of the cast at this and another theatre.

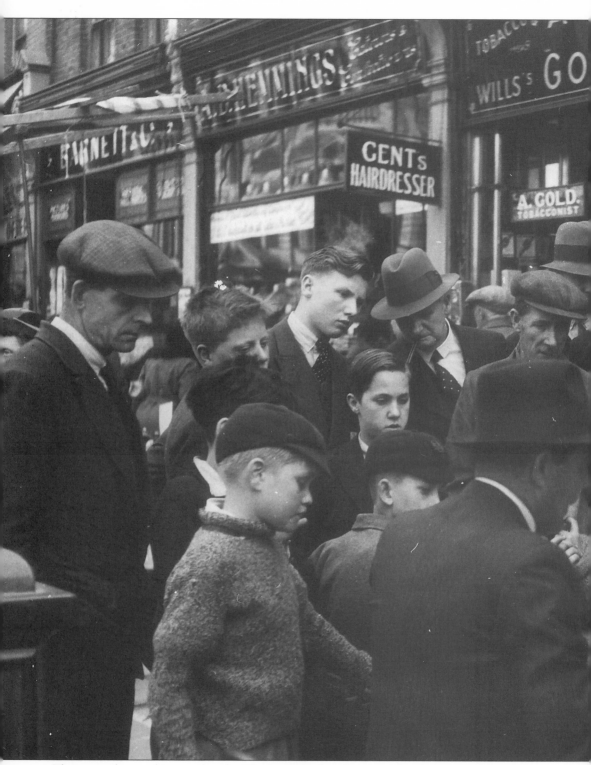

There was always a big crowd at the Woolwich market during the lunchtime periods and there was always plenty to see and hear to keep every one amused and even willing to buy the

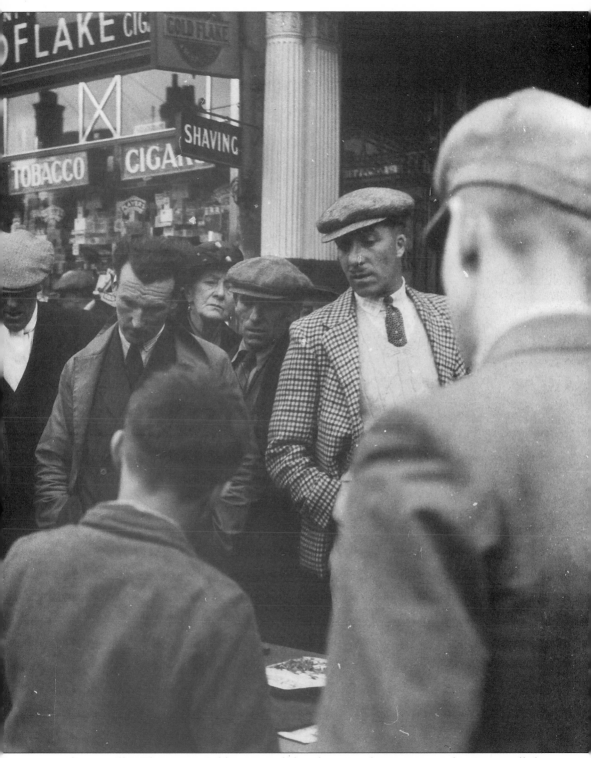

remedies on offer. The story would go around that 'he was a famous surgeon but got expelled because he performed an illegal operation'.

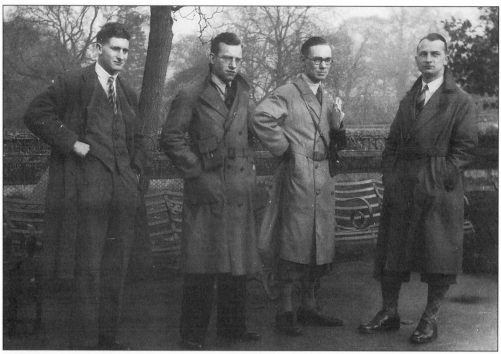

Part of our small photographic group – yours truly on the left – recorded on an expedition to London.

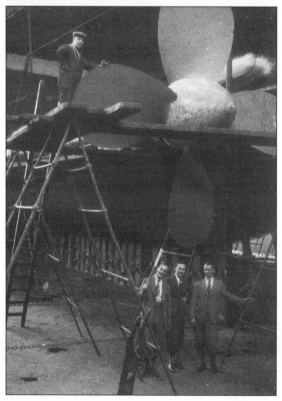

Three of our members at the bottom of a dry dock in the Royal Albert Dock, 1934. By writing to the Port of London Authorities we got permission to go on the dock and the locks.

Six
To London

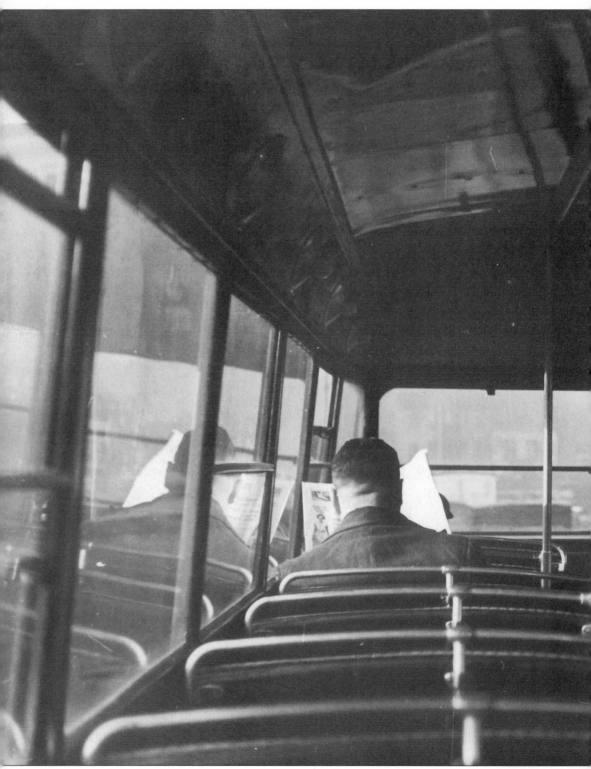

To London from the top of a bus. A point policeman can be seen ahead. Bus Nos. 5, 15 and 40

went from Plaistow, Barking Road.

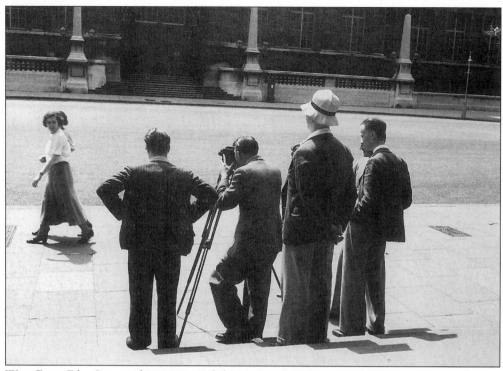

West Essex Film Society shooting in Exhibition Road, Kensington, 1934. One of our members became a professional cameraman, another became Director of the British Film Institute.

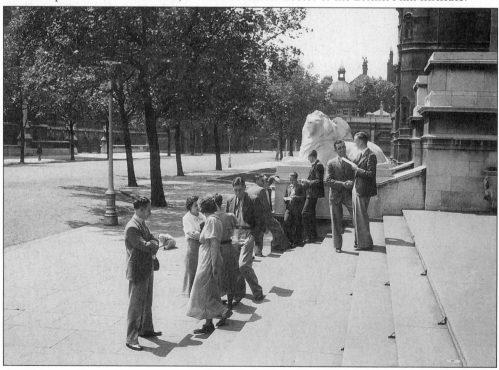

A still from a film under preparation called *The Student*. Note the absence of cars in the road.

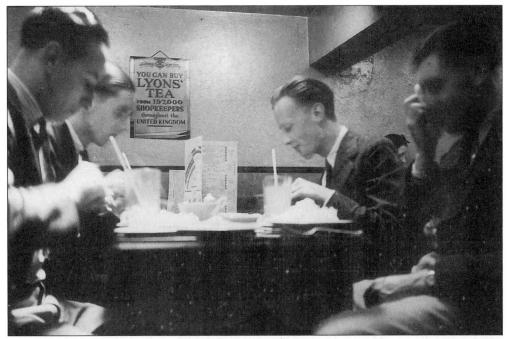

West Essex Film Society on location and having refreshments in a typical Lyons teashop of the time. On the right near the wall is the organiser and secretary, Arthur Watson from First Avenue, Plaistow. He managed a small cinema in Stratford through the week.

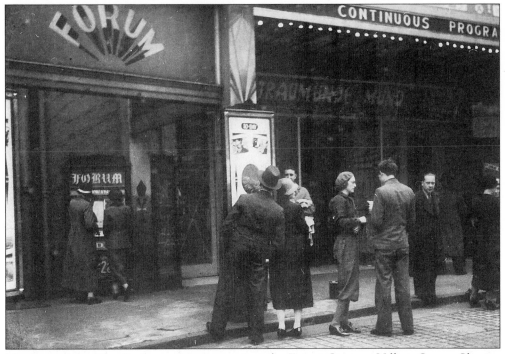

Members of the Film Society waiting to go into the Forum Cinema, Villiers Street, Charing Cross. Viewing of the German or Russian films, which were typically shown here was enlivened by the sound of the trains passing overhead!

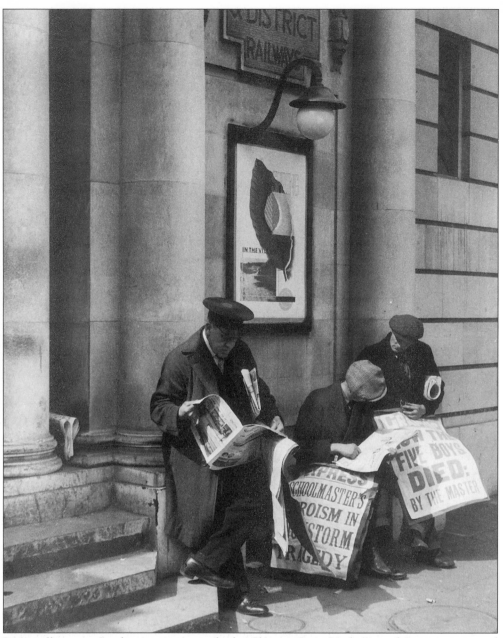

Paper sellers on a Sunday morning outside the Charing Cross Underground Station, as it used to be called.

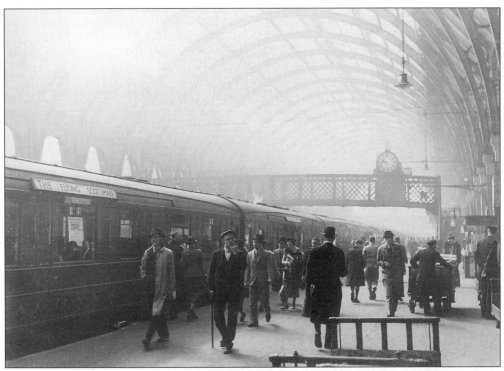

The *Flying Scotsman* at Kings Cross Station fifteen minutes before it was due to leave – I travelled on this train but took this record of platform activity, 1935.

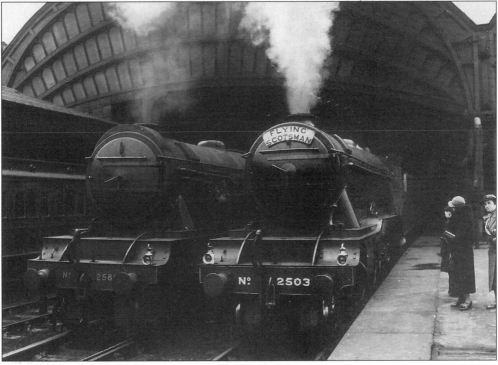

The engine ready to go.

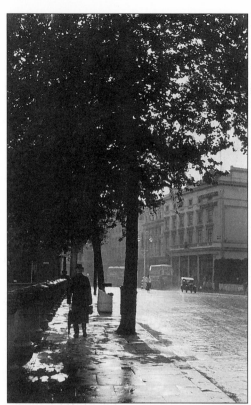

A solitary figure with bag, umbrella and a raincoat turning green with long use. Opposite is Hamptons and an Austin 7 in the road.

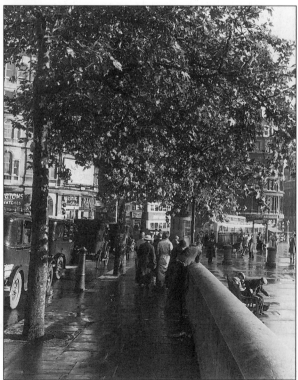

The east side of Trafalgar Square with taxi-cabs in the near lane. Bravingtons shop is on this side.

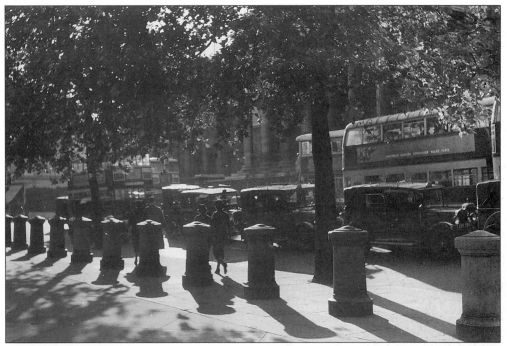

The north side of Trafalgar Square facing the National Gallery.

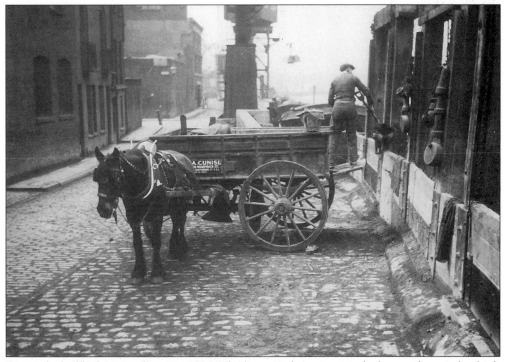

Disposal of rubbish onto a barge in 1934. The horse and cart is typical of many thousands which worked in the London area, and probably many other places, for light construction and other general work. This one is at the South Bank.

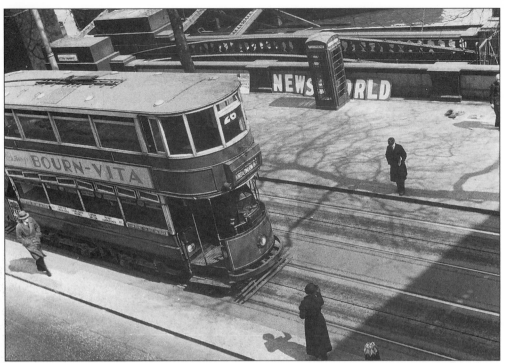

Crossing the road on the Embankment. The schoolboy had possibly crossed to get a better view of the *Discovery* which was moored at this place. The tram is the big L.C.C. type with road level trolleys and open front.

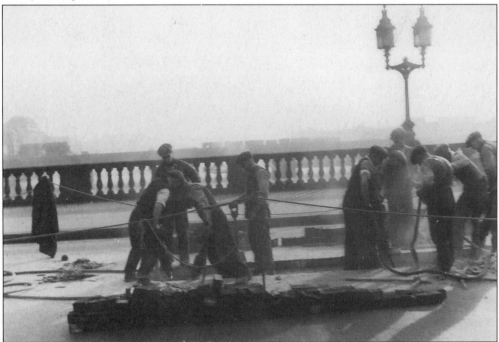

An activity to gladden the heart of every cyclist and motorcyclist who had skidded on wood block surfaced roads. Removing the wood blocks along the Embankment in 1934.

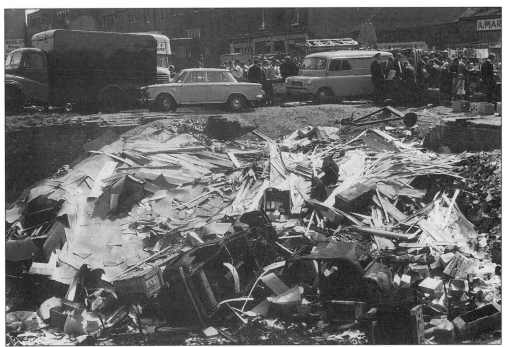

Despite the 'big hole', which presumably is something not cleared up from the Second World War, business goes on as usual on a Sunday morning in the Middlesex Street-Petticoat Lane-Club Row area for merchandising *c.* 1955.

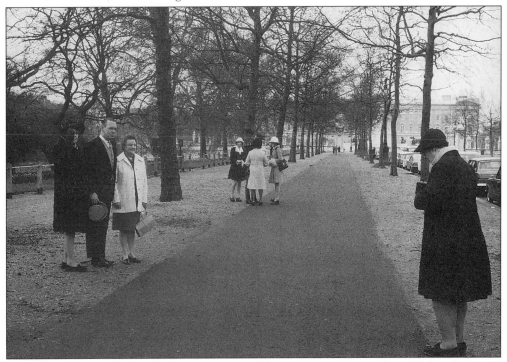

Waiting to go into Buckingham Palace for an honours presentation. The elderly relative, or perhaps nanny, takes a picture on her box brownie. The fashions are typical of the 1970s.

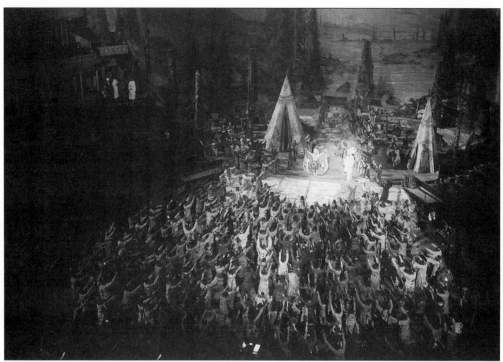

Hiawatha at the Albert Hall, 1938. This was the point when the Christians came in from the left and everyone was still for a moment which helped my photography!

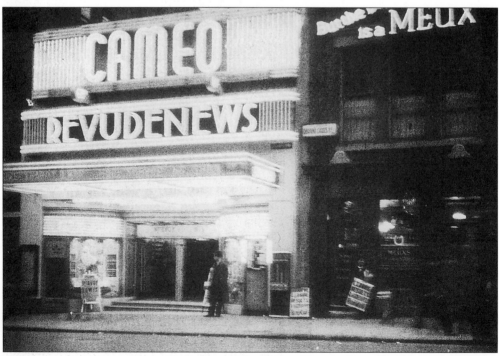

The Cameo was a news theatre on the west side of lower Charing Cross Road.

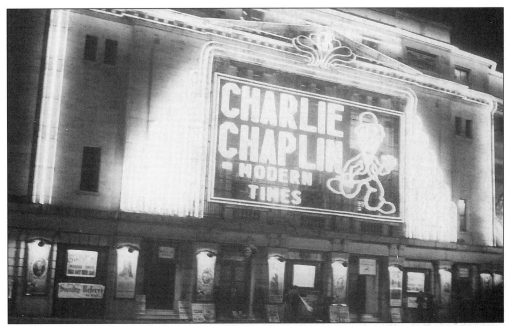

Charlie Chaplin was the star of *Modern Times* which was at the 'Tivoli' in the Strand at the corner of John Adam Street.

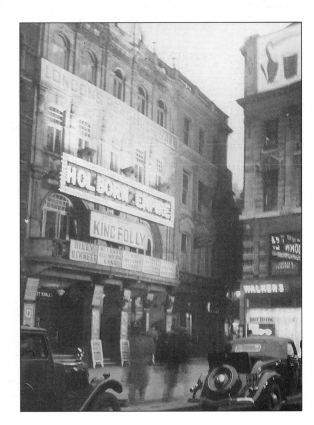

This is the Holborn Empire, advertised as London's Real Musical Hall.

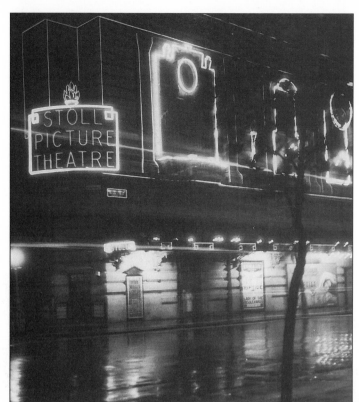

The 'Stoll Picture Theatre' on a wet night in 1934. This flourished in Kingsway off the Strand.

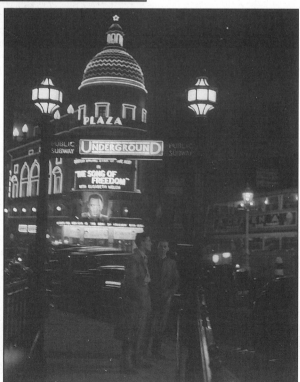

Piccadilly by night with traffic congestion and *The Song of Freedom* at the Plaza.

The Windmill before it went over to
continuous variety shows. This show was
Tulip Time for which the crowd is
queuing.

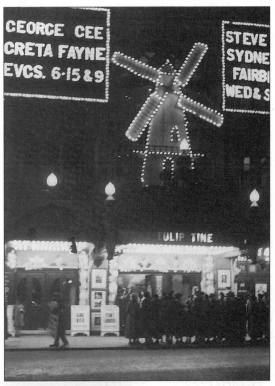

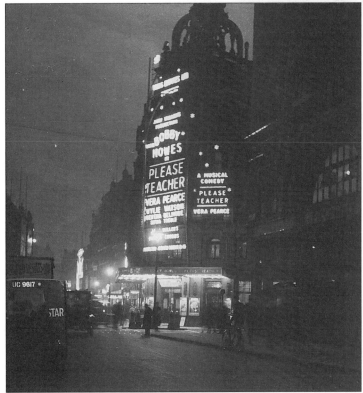

Theatreland with a
musical comedy on
offer. Newspaper vans
and taxis are prominent
in the traffic.

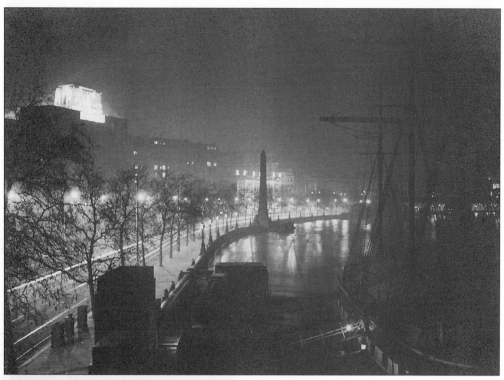

Discovery moored on the river, Cleopatra's Needle on the Embankment and the illuminated clock of Shell-Mex on the left *c.* 1934.

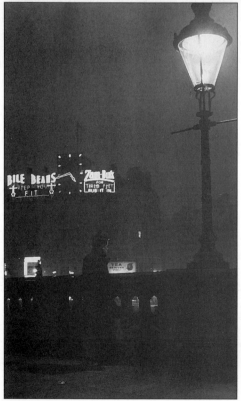

Bile Beans and Zam Buk keeping you fit and reviving your tired feet at Trafalgar Square in 1938, with my friend Haley in the shadows.